MARJORIE CONTENT *Photographs*

MARJORIE CONTENT

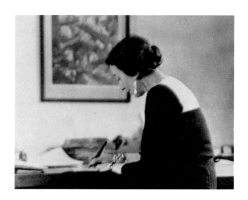

Photographs

JILL QUASHA

*with essays by Ben Lifson and Richard Eldridge,
and Eugenia Parry Janis*

W. W. Norton & Company
New York · London

BOOK DESIGN AND COMPOSITION
 Anthony McCall Associates
MANUFACTURING BY
 Stamperia Valdonega, Verona, Italy
JACKET PHOTOGRAPHS:
 FRONT: *Susan Loeb,*
 Marjorie Content, 1930;
 BACK: *Self-portrait,*
 Marjorie Content, c. 1928
FRONTISPIECE:
 Marjorie Content, 39 West 10th
 Street, New York, Spring 1934

LIBRARY OF CONGRESS CATALOGING IN PUBLICATION DATA

Quasha, Jill
 Marjorie Content : Photographs / Jill Quasha; with essays by
Ben Lifson and Richard Eldridge, and Eugenia Parry Janis.
 p. cm.
 ISBN 0-393-03682-0 : $29.95 ($37.50 CAN.)
 1. Content, Marjorie, 1895–1984. 2. Photography, Artistic.
3. Women Photographers—United States—Biography. I. Title.
TR140.C66Q37 1994
770'.92—dc20 94-16848
[B] CIP

ISBN 0-393-03682-0
W. W. Norton & Company, Inc., 500 Fifth Avenue, New York NY 10110
W. W. Norton & Company Ltd., 10 Coptic Street, London WC1A 1PU
1 2 3 4 5 6 7 8 9 0

CONTENTS

Acknowledgments

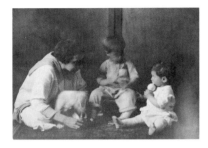

To Susan Loeb Sandberg

To uncover facts about an unknown artist requires the help of many people. I owe the greatest debt of gratitude to Marjorie Content's daughter, Susan Loeb Sandberg, who graciously and tirelessly participated in every phase of the research. She and her son Keith and daughter-in-law Nancy opened their homes to me and gave me their confidence, cooperation, time, and valued friendship.

I must also thank Content's stepdaughter, Margot Toomer Latimer, for so generously sharing with me her memories of Content and of her father, Jean Toomer.

Ben Lifson deserves special thanks both for his profile of Content and for his help on almost every aspect of the project.

My sincere thanks go also to my other collaborators: Richard Eldridge, for his clear-sighted research and solid contribution to Content's biography; Eugenia Parry Janis, for her poetic and insightful essay about Content's work; Thomas Palmer, for his masterful negatives, beautifully printed by Martino Mardersteig; John Bernstein and Anthony McCall for their superb design; and Sue Potter for her superlative preliminary copy editing of *all* the boring bits.

I am indebted to Jim Mairs for his enthusiasm and for bringing the book to its fullest expression. I thank Cecil Lyon

6

Fig. 1. *Marjorie Content Loeb with Jim and Susan Loeb, Palo Alto, 1917–18*

for her editorial assistance, Tabitha Griffin for her untiring work on the manuscript above and beyond the call of duty, and Marian Johnson for her excellent copy editing.

I am also grateful to the American Federation of Arts for their efforts with regard to a traveling exhibition of Content's work, and to Barbara Millstein for providing access to her recent research touching on Content's milieu and her artist friends of the 1920s; Tim Werkamp of the Civil Reference Branch and Dale Connolly of the Still Pictures Branch of the National Archives, for their help with picture research; Benjamin Primer of Princeton University, for the photograph of Content's first husband, Harold Loeb; and Doris Bry and Sarah Greenough, for locating photographs of Jean Toomer by Alfred Stieglitz.

Mary Frank Loeb, Flora Stieglitz Straus, Diana Heller, Alexandra Kizinski Babione, Doris Bry, Barbara and Charles Ingerman, and Sue Davidson Lowe all shared their personal memories of Marjorie Content with me.

Special thanks are due to Nicholas Callaway, who first showed me Content's photographs thirteen years ago, and to Vincent Vallarino, who helped find many photographs.

Richard Benson, Shelley Dowell, Diana Edkins, Diana Gaston, Elizabeth Glasmann, Adeline Gwynne, John Gwynne, Eric Himmel, Elizabeth Valk Long, Leila Hadley Luce, Michaelyn Mitchell, Christopher Phillips, Victor Schrager, Adele Ursone, and Eugene Winick also gave special support in the form of advice and valuable suggestions.

I am indebted to Brooks Johnson for the unwavering faith expressed by him and those at the Chrysler Museum in their early and continuing support of an exhibition of Content's work; to Maria Morris Hambourg also for her faith both in Content's work and in my vision of the project—a faith with qualities I find nowhere else; to Dorothy Norman who so generously allowed us to reproduce her photograph; and to the many collectors who so kindly lent photographs for the exhibition and gave permission to reproduce them here.

Finally, my heartfelt thanks to Richard, Chloé, Paz, and Sammy for their unflagging love and for their patience during the many times that this project took my attention away from them.

JILL QUASHA

7

FIG. 2. *Marjorie Content, Summer 1934*

INTRODUCTION

A handful of photographs by Marjorie Content surfaced about fifteen years ago. When I saw them two years later, I felt sure I was looking at intimations of a hitherto unknown but strong artist at once representative of her era and unique unto herself. These few small pictures—most slightly smaller than 3 x 4 inches, views of New York streets and studies of clouds and flowers—eloquently expressed the ideas of Alfred Stieglitz and his influence upon his times and yet had qualities found neither in Stieglitz's work nor in the work of his circle: calm, intimacy, delicacy, restraint, refinement, and simplicity. Moreover, Content's handling of her subjects seemed so much informed by simple, elemental emotions and responses—curiosity, wonder, love— that no matter how deeply her pictures were rooted in the style of their time, her lyrical voice and freshness of vision seemed undated, as if the work had been made today. The pictures were like small gems whose glow and perfect craftsmanship strike you long before you take stock of how, when, or in what style they were cut. Clearly, here was an artist who had undeservedly slipped through the net of photographic history.

When these pictures emerged, all that I was told about Content was that she was a friend of Stieglitz and an intimate friend of Georgia O'Keeffe; that she was inspired to start photographing in the early 1920s by the art she saw in Stieglitz's gallery; that Stieglitz encouraged her, taught her to print, and was, at the beginning of her brief photographic career, her informal mentor. When in the course of my research I met Content's daughter and grandson, Susan and Keith Sandberg, I began to learn that only some of this was true. As I saw more of her work, little by little, I was persuaded that it should be more generally known. And the more I learned about Content herself

9

and why she lapsed into inactivity after so brief a flourishing—fifteen years is not long in the life of a deeply talented woman who lived well into her eighties—the more I thought her life should also be made more accessible.

"She never considered herself an artist," her daughter, Susan, told me, and this is the family's general and often-repeated impression.

My collaborator on this project, Richard Eldridge—coauthor of *The Lives of Jean Toomer: A Hunger for Wholeness* (1987), a biography of the Harlem Renaissance novelist Jean Toomer, Content's fourth husband— uncovered much data to indicate that this gifted woman was more comfortable acting as handmaiden and midwife to the gifts of others, mostly men, than to her own. She was a good listener, had good taste, was articulate, and had an intuitive response to the needs of other artists. Talented and visionary men and women flocked to her, and she easily and spontaneously gave them spiritual support. To the men of genius in her life— including three of her four husbands—she gave unselfish devotion.

This was generosity to a fault, for it often distracted her from her own work and was ultimately a determining factor in the decline and eventual cessation of her artistic productivity. But Eldridge's data and the accounts of her family suggest that her giving to other artists was part of her makeup, not an escape from the demands of her own talent. She had not only the soul of an artist but also the soul of a muse. In serving other artists, she fulfilled this latter part of her nature. Whether it was the stronger part, more justly and appropriately employed than her own creative nature, or whether the dramatic conflict between Content the artist and Content the muse was a tragic one, only further investigation and the evidence of her work will tell.

In her own time Content's work not only won the respect of
Stieglitz and O'Keeffe but was published in the French journal
Photographie. It was therefore recognized in Europe as being in the same
arena—figured in terms of quality, integrity, and artistic understanding
—and deserving of the same chance to survive as the work of Henri
Cartier-Bresson, Florence Henri, André Kertész, Dora Maar, Martin
Munkacsi, Man Ray, Maurice Tabard, and other major and minor photo-
graphers of the period.

Approximately one hundred exhibition-quality pictures from
the late 1920s to the early 1940s—to me Content's strongest period—
are still extant. With the help of her family, who also thinks the world
should see again something of what Content achieved, I have chosen
for the plates in this volume seventy-two photographs: still lifes,
portraits, street scenes, and flower and cloud studies, along with some
landscapes, portraits, and various studies from New Mexico—pictures
that attest to the fact that despite a life whose achievements were so
often ephemeral, or expressed through other people's work, Content left
behind a permanent and eloquent record of her own unique sensibility.
The photographs will not change our sense of photographic history.
Nonetheless, I am persuaded that they will add to our understanding of
what photography is capable of, especially in the lyric mode. They are
also a significant addition to our understanding of photography's beauty,
and of its pleasures.

Jill Quasha

Marjorie Content was born in 1895 into one of Manhattan's wealthiest and most prominent Jewish families. A shy, retiring girl who struck her high school friends as lacking drive, purpose, and interests, she lived for over thirty years in the shadows of a series of larger-than-life, ambitious, and flamboyant men and women who loomed large on Manhattan's social, financial, and cultural scene in the first quarter of this century: her father, the stock-broker Harry Content; her first husband, Harold Loeb, founder/editor of the avant-garde journal *Broom*; the photographer Alfred Stieglitz; painters Georgia O'Keeffe and Henry Varnum Poor; writers Maxwell Anderson, Kay Boyle, Lola Ridge. Even in accounts of the intellectually ambitious bookstore Content joined in her twenties, she is a pale figure who keeps the books in the back office. In histories, biographies, and autobiographies of the period, she appears as a marginal, occasional figure, a friend, a supporter, an encourager, with no artistic talent, ambition, or achievement.

However, by the mid-1920s, unbeknownst to most of her circle, she was making photographs that, emerging now, assure her a permanent place in the history of American photography. By 1924 Stieglitz had called a group of her pictures "splendid."[1]

We don't know precisely when she began to take pictures; nor did she ever say why she had begun, and her back-ground holds no clue to the sudden flour-ishing of her talent. She studied art in high school, visited art galleries in her late teens, and during her mid-twenties

Fig. 3. *Harry Content*

immersed herself in the new art and literature of
the period; but so did many wealthy, cultured
young women of her circle who did not go on to
make beautiful pictures.

Nor did Content's childhood provide her
either with a knowledge of art or with an idea of
the artist that might have led her to believe that
hers was an artistic nature. If there were "no money
problems," she wrote of her early life, "there was
also nothing else. Neither of my parents ever read
anything but the newspapers, no music...no interest in the graphic
arts...there were no tales from the past either."[2] If she detected
an inner imaginative world, it is possible she rejected it as a form of her
mother's melancholia—Ada Content was in and out of sanitariums
throughout Marjorie's childhood, and at an early age Content made
"a private vow never to be like" her mother "in any way."[3]

It was her father who fascinated her. Harry Content was a
stockbroker who made and saved fortunes for J. P. Morgan, the
Baruchs, Guggenheims, Lewisohns, and others, and won and lost them
for himself. In 1938, aged seventy-seven, he became the acknowledged
dean of Wall Street. Although he loved creating wealth and loved
the surprise of the sudden coup long prepared in secret, neither wealth
per se nor his reputation as "a concentrated financial devil" whose
"white teeth" looked "when he was stalking...like those of a wolf," and
whose rivals were "switched into eternity,"[4] was a sufficient object
of his ambition. He devoted considerable intelligence and energy to the
creation of a dazzling social persona whose major traits were splendor,

13

Fig. 4. *Marjorie Content*

willfulness, and a singularity so pronounced as to be at once eccentric, visionary, and esthetic.

Suites in luxurious hotels, the Saint Regis, the Sherry Netherlands, were his homes. He wore a fresh carnation in his button-hole, smoked gold-tipped cigarettes, reserved whole restaurants for his dinner parties, gave lavish holiday gifts to friends and associates, was for a time the companion of financier Diamond Jim Brady in the night world of Broadway, had sensitive taste in food, period furniture, and jewelry, entertained on a 110-foot yacht berthed in the Hudson River, was president of a hunt club and a country club but cared for neither horses nor golf, furnished his offices with heavy, old-fashioned mahogany and black-leather-upholstered furniture, chased amateurs from the market, would have no women clients,[5] and when his wife moved per-manently to a sanitarium he lived openly with his mistress, the actress Margaret Hawksworth.

He and Marjorie "adored" each other "blindly," Content said, "but without any real understanding."[6] Yet now each seems a version of the other: Harry Content, the proto-artist, a portraitist whose sole subject and masterpiece was himself; Marjorie Content, the dormant artist whose creation was for a long time a counter-version of her father's iridescent persona, singular for her shyness, silence, and simplic-ity…as willful, articulated and absolute as her father's magnificence. Yet "HC," as everyone called him, including his daughter, never under-stood his daughter's choices, and even after she became an artist she failed to perceive the esthetic element in his use of wealth.

According to Content's lifelong friend Flora Stieglitz Straus, in high school Content was a "simple," intellectually "passive," but socially

"gay" girl with a husky voice; she was always "well groomed" and dressed with "elaborate simplicity"; she also, Straus said, kept horses and rode every day in Central Park. Straus, Content, and Dorothy Obermeyer (later Schubart) often visited Flora Stieglitz's uncle, the photographer Alfred Stieglitz, in his gallery, but these were social visits: Content had, Straus recalled, "no interest in art."[7] To her Stieglitz was simply "Uncle Alfred."[8]

 The young Content was also intensely critical of others. "I feared her criticism," Straus said. Content put it this way: "[My] god became 'honesty'—frankness—my abomination...a sentimental uncriticality." She carried her frankness "to a ridiculous extreme," hurting people's feelings with gratuitous harsh comments. This, she acknowledged, "may also have been a device to be 'different'—a way of making myself noticed—myself, who otherwise was not loud, not showy, not outstandingly anything."[9]

 "Life began to open out" for her at Miss Finch's School, whose socialist/feminist principal hired guest teachers "from all walks of life...Union organizers, actors, writers, artists, etc. to teach Current Events." It was a "real breakthrough [sic] the blind wall which had surrounded my life up to that time."[10]

 At nineteen she married Harold Loeb of the Guggenheim family, an act that took their friends and family by surprise. There had been no apparent courtship, and Content said later that they married impulsively. "Only the immediate relations witnessed the ceremony,"

15

Fig. 5. *Harold Loeb, class picture, Princeton, 1913*

a newspaper said. "The bride was unattended. She wore a travelling costume of dark blue. Shortly after the ceremony Mr. Loeb and his bride left for…Empress, Alberta, Canada, where they will reside."[11] Their seeking the simple, rugged life in Canada was another aspect of their inclination for creating effect.

In addition to his flair for the unconventional gesture, Loeb was a Princeton graduate with literary ambitions and the ability to befriend first-rate writers like Ford Madox Ford and Ernest Hemingway. In *The Sun Also Rises*, Hemingway actually used Loeb as his model for the character Robert Cohn. Loeb also had excellent literary judgment and a sincere interest in the new art of the 1920s.

Six months after Content and Loeb settled in Canada, World War 1 began and they moved back to Manhattan, where their two children were born: Jim (1915) and Susan (1916). Content gave birth to both children at home, by natural childbirth, attended by the general practitioner Leopold Stieglitz, Alfred's brother. The family then moved to California, where Loeb managed a Guggenheim firm, but they were back in Manhattan by 1918, where they finally broke with their families' values in a serious way by choosing careers in the ill-paying and socially obscure field of contemporary literature and art.

Content found her direction first. In 1919 she joined the managerial staff of The Sunwise Turn, one of Manhattan's few bookstores devoted to new writing and thought and the first to have been founded and run entirely by women. Writers Edmund Wilson, F. Scott Fitzgerald, and Sherwood Anderson kept up with new American and European writing there, as did publisher Alfred A. Knopf, who often bought in large quantity.

In 1921 Loeb established his place in New York's intellectual world by founding *Broom*, a journal of new writing and art, which he also edited. The writer Kay Boyle, from 1921 to 1923 secretary to *Broom*'s managing editor, the poet Lola Ridge, wrote in 1968 that *Broom* "was probably the handsomest and arty-est of any literary publications of its time, printed…on very elegant paper, and published in Italy by [Loeb], Arthur Kreymbourg [*sic*], and a number of other temporarily expatriate writers."[12] *Broom* ran for three years, publishing such writers as Louis Aragon, Sherwood Anderson, Jean Cocteau, Hart Crane, e. e. cummings, John Dos Passos, Paul Eluard, Robert Graves, Marianne Moore, Gertrude Stein, Wallace Stevens, William Carlos Williams, and Virginia Woolf, and reproducing pictures by André Derain, Juan Gris, Fernand Léger, Henri Matisse, Amedeo Modigliani, and Pablo Picasso.

Loeb set up *Broom*'s offices in the basement apartment of the Greenwich Village brownstone that Harry Content had bought for Marjorie, but, preferring long trips to Europe in search of material and friendships with artists, he relegated the day-to-day management to Ridge and Boyle. While he and Hemingway were running with the bulls in Pamplona or drinking with other writers in Paris, it was Ridge who, with modest weekly tea parties, turned the basement offices of *Broom* into a Manhattan literary salon.

As Loeb largely neglected Content and the children, Content's shyness made her an outsider to the literary world he had opened up to her, although she gave generously to it. "Where the money for the tea and cakes and lemons and milk came from every week," Boyle writes, "one did not know. Perhaps from Marjorie of the warm, shy, generous heart and madonna face."[13] But during the open houses Content merely

watched and listened. By the time divorce pro-
ceedings began, "a portion of Marjorie's being
seemed shadowed and silenced. She was even
timid about coming down to the office when
people were there, but if Lola and I were alone
she would come tentatively down the basement
stairs, with her two young children following.
I was shy with her as well, as shy as if I had come
upon a tender-eyed gazelle on a forest path."[14]

That Content later emerged from these shadows, flourished
briefly as a designer of costumes for the theater, and eventually made
the photographs for which she is known today seems mainly due to her
having fallen in love with the painter Michael Carr in 1922.

When she met Carr she was twenty-seven, the divorced mother
of two small children, ex-partner in a bookstore, with a comfortable
income and a beautiful expensive house but no work of her own. He
was forty-five, a seasoned artist and a working set designer with clients
ranging from the great producer/director Max Reinhardt and the great
Broadway impresario Florenz Ziegfeld to avant-garde theaters; he was
also famous for puppets he designed and built for the stage. He was
tall, lanky, and bald on top and wore a long bushy beard which he trans-
formed into a rakish goatee and long, thin, curling mustachios in the
many satirical self-portraits that adorn his letters and notes.

For the five years of their courtship and marriage, he showered
Content with exuberant love preserved now in the notes he sent her on
every possible occasion. When he couldn't reach her by phone, he wrote
a note; when he rang her bell and she wasn't home, he wrote; when he

18

Fig. 6. *Michael Carr with
Susan Loeb, c. 1923*

noticed that his mind was dwelling on her name or on the
night he had just spent with her, or on the night to come,
he sent a note. These small rectangles of thick matte paper,
blue, beige, brown, or cream-colored and bordered by thin
art-nouveau lines in Carr's hand, show Cupids, flowers,
hearts, sunbeams dancing on forest pools, moonlit glades
and starry nights. On one, three moons, as bright as suns
and joined by a rainbowlike arc of bright light, streak across
a black sky while Carr himself gazes in wonder at the three
bright months of their courtship. The notes are saved from
sentimentality by Carr's self-conscious exaggerations and
by the challenge he seems to have set himself of switching
the ground with each note. He goes from extreme to
extreme, sometimes calling Content "the Infanta," then "the
most charming person in New York," and always composing
rhapsodies on her name. He figures their love as a richly

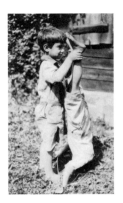

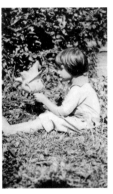

decked-out Spanish galleon held aloft by a plump Cupid and pictures
himself variously as a melancholy clown staring into her window, a
court fool at the Infanta's feet, or—when he cannot find her at home—
the "stumbling...last inhabitant" of the "desert island" of Manhattan.[15]

 With Jim and Susan he was equally tender, attentive, festive,
and inventive. He covered the walls of their bedrooms with abstract
murals, watched parades with them from their bedroom windows, and
wrote and put on puppet shows for them in a theater he built in the
living room.

 He also brought Content into his work, first as his assistant,
then as his collaborator, until one day she overheard him say into the

19

Fig. 7. *Jim and Susan Loeb, New City, New York, c. 1923*
Fig. 8. *Susan Loeb, New City, New York, c. 1923*

telephone to a client, "Miss Content does all my costumes." His belief
in her at that moment was more cogent to her than her inexperience,
and she accepted the commission. Within months she had her own staff
and clients ranging from avant-garde Greenwich Village playhouses
to Broadway, and her costumes were featured in fashion magazines and
theatrical journals.

Until Carr, Content's expression of her inner emotional,
esthetic, and spiritual vision had been sporadic, its results fragmentary,
affected, or, with Loeb, merely gestures. With Carr she found someone
to whom companionship, domesticity, intimacy, love, and work were
activities of a continuously unfold-
ing, deliberate way of life. The
climax of their shared effort was
the large fieldstone house they
designed and built together on a
tract of wooded hills near New

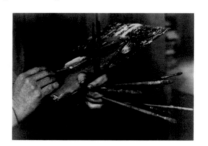

City, New York, in rural Rockland County, about fifty miles north of
Manhattan and west of the Hudson. The first residents on this land were
Content's friends the writer Bessie Friedman Breuer and her husband
the painter Henry Varnum Poor. Poor had also designed and built houses
there for other artists, including the playwright Maxwell Anderson and
his wife, Margaret, as well as Content's friends and former teachers
Arthur and Mary Mowbray-Clarke.[16] Other artists, including Stieglitz
and O'Keeffe, were frequent visitors.

According to Content's daughter, Susan Sandberg, the five
years in Rockland County until Carr died of pneumonia in 1927 were
the happiest period in Content's life. And it was here that the artist

20

Fig. 9. *Henry Varnum Poor's hands and palette,
Winter 1933*

latent in Content came into being. She must have begun to photograph before the building of the house, for it was her pictures of Carr laying its foundations that Stieglitz called splendid. They are badly faded now and look very much like snapshots; but by this time Stieglitz believed that photographs were best when they looked like "just photographs."

By 1926 Content was making the pictures by which she is known today. Small,[17] exquisitely printed, and with a slight reddish-brown tint,[18] they are pictures of ordinary, everyday things: views from her windows; the faces, limbs, and hands of her children and friends; studies of flowers. She worked without esthetic program, fascinated by the inexhaustible mystery of the surfaces of things touched by ordinary light. Her rhetoric is that of the concrete, direct, and simple statement. Her best work seems almost artless in its avoidance of visual drama and effects, in its rigorous dependence upon the basic elements of light, line, surface, and composition. As Lawrence Durrell says of the poet William Wordsworth, Content "pitched" her work "beyond the reach of the contemporary 'poetical' style,"[19] as though only by distancing herself from the esthetic trends of her day could she make her pictures express her direct lyrical response to the visible world. Her gaze is extraordinary only in its apparent steadfastness and duration. The total effect is of a preternatural stillness, an almost religious calm, informing each subject, so that her pictures seem to record not an objective but a poetic truth.

However, Content apparently tried to neither fathom her own artistic nature nor articulate what is commonly called "an esthetic." In the thousands of extant pages of her journals and letters, we find no theories, no accounts of inspiration, no plans for short- or long-term projects, no comments on recently made work, no anecdotes about

making work, no reports of conversations with other artists, no paraphrases of things read in books on art and artists…no body of writing, in other words, such as many artists build up in journals, notebooks, and letters and return to often enough so that it can sustain them when inspiration or self-confidence gives way. She acknowledged the general importance of such things when she wrote in 1936 that one's picture of oneself "should not be…limiting…but rather in the nature of an ideal toward which one lives…a vision of oneself [that] comes from the psyche and is conscious."[20] A few months later she effectively said that her picture of herself as a photographer had been just that, too limiting to help her sustain her effort past a certain point: "In photography I knew I was getting to be a better workman…(and I suspect that when I could no longer observe improvement, that was the point at which I lost intense interest)."[21] Regarded as closely as existing documents permit, then, Content's life attests to the necessity not only of love but of discourse to the making of art; for it attests to the havoc art can suffer when the channels of love and understanding are both diverted and blocked. As Content's life after Carr shows, the failure of love and her career-long silence closely paralleled the decline of her photography.

22

 After Carr's death in 1927, Content sold her house, took a small apartment off Washington Square, photographed intensely throughout 1928, and in 1929 fell in love with and married the poet Leon Fleischman. Fleischman proved an unreliable husband, a cold stepfather, an erratic poet, and a drunk. When life with him in her small apartment became intolerable, Content and her children moved to a large brownstone on West 10th Street. In 1931 she went to Paris to

meet Fleischman in a failed attempt to save the mar-
riage. During the summers of 1931, 1932 and 1933,
she and the children camped across the country
with Gordon Grant, a young painter who was also a
student of Native American art and dance and
who introduced her to the Southwest tribes who had
befriended him.

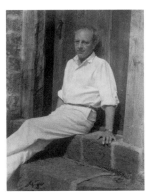

 Content's landscapes and nature studies
from these summers show a sudden change in style. The lushness of her
nudes and flower studies and the lyricism of her architectural studies and
still lifes gave way to rigorous analysis of pictorial structures in nature:
tapestry-like expanses of striated rock in canyon walls, and—in a study
of a fissure running obliquely down the face of a flat rock—abstract
compositions. And with a picture of Grant in the car, seen through the
windshield, part of his face obscured by the reflection in the glass of a
bright blank sky, the other part revealed by the shadow of Content,
her head bent over her camera, she discovered light and shade not as
qualities of the subject but as the elements that create the subject. It is
as though imbued with the bold improvisational spirit of the journey
and deprived of the familiar sights of everyday life in the East, Content's
eye, already disciplined to the close observation of light, line, and
surface, discovered in the West a world of form barely observable in
her eastern photographs.

 In New York each winter she kept photographing passionately.
The darkroom on West 10th Street became her sanctuary, and her children
saw little of her except when they posed for her. In 1932, the French jour-
nal of art *Photographie*—whose contributors included Berenice Abbott,

23

Fig. 10. *Leon Fleischman*

Henri Cartier-Bresson, André Kertész, Man Ray, Charles Sheeler, and Edward Weston—published several of Content's photographs. Obviously, she had taken herself seriously enough to have sent her work out for consideration in a professional arena. She was published only one other time—again in *Photographie* in 1935—but this was probably

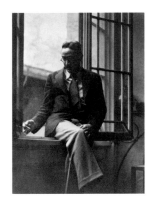

a result of her lifelong reticence. Nonetheless, art was her life, it seems, until she fell in love with the poet and novelist Jean Toomer.

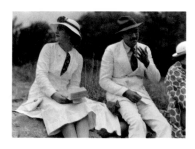

In the 1920s Toomer was a prominent writer in the movement of African-American artists known as the Harlem Renaissance and is best known today for his lyrical novel *Cane*. He published in *Broom* and was part of Stieglitz's circle. Content had been aware of him from the early 1920s, but it was O'Keeffe who set the stage for their meeting. Toomer appears as a character in O'Keeffe's letters to Content beginning in December 1933. In January 1934, she tells Content about an evening when "Toomer began thumping with Indian rhythm on the bottom of a tray, and I got the shivers all over—through the roots of my hair—you must meet him—you will like him I think." O'Keeffe closes with, "You must meet Toomer—you will like him."[22]

In Content's photographs of 1934 Toomer is a tall, handsome, lithe, and languid man with short-cropped hair and a trim mustache; his eyes, behind steel-rimmed spectacles, are bright; he looks about him

24

with an expectant curiosity, a half-smile often playing over his face. He wears white suits and white shirts open at the collar; sitting, crouching, kneeling, or standing, his long body composes itself easily and esthetically. By the early 1930s he was more a mystical writer than an imaginative one, having come under the influence of the mystic philosopher George Ivanovich Gurdjieff. From Toomer's letters of 1934, one gathers that he believed that a universal spirit dwells within all human beings and that with discipline one penetrates appearances and reaches this spirit, from which moment one's life becomes an emanation of it. His effort in the 1930s was to reshape his writing to embody this truth.

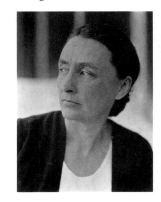

To Content, who grew up wondering where her true self lay and who, according to her daughter, Susan Sandberg, always tended to put others on a pedestal, such a man must have been immensely attractive. Late in life she acknowledged that from their first meeting "I gave my whole self to him—I thought or felt that he was 'above' criticism...a human incarnation of a superior being."²³ She called their relationship an incorporation, as though he had absorbed her spiritually and bodily. She accepted him as lover and teacher, perpetually thought she was failing him, and for years after they met wrote hundreds of pages on his themes and in his style.

She fell in love with him shortly after the bold changes in her style had begun, and in her letters to him of the summer of 1934 we can watch her struggling with the conflicting demands of love and art and gradually yielding to love. The letters date from June 1934, on a trip she

25

Fig. 13. *Georgia O'Keeffe, Alcalde, New Mexico, 1934*

and O'Keeffe took from Chicago to Taos, New Mexico, one of whose purposes was for Content to obtain a divorce from Fleischman. After the divorce, Toomer was to join them, and he and Content were to marry.

The exchange of letters begins June 7, 1934, with a postcard from Content to Toomer, postmarked Clinton, Iowa, and a letter from Toomer to Content, postmarked Barrington, Illinois—they are some hundred miles apart and separated by a day. Toomer had driven with her from Manhattan to Chicago, then went north to the home of his late wife's mother, Laurie Latimer, in Portage, Wisconsin, to be with his twenty-two-month-old daughter, Margery (called Argie and, later, Margot), and wait for Content's divorce.

Content's letters from the road are rich in anecdote and detail and describe a journey full of high spirits, improvisation, a thirst for adventure, and a delight in art making. She and O'Keeffe neither hold to a schedule nor accommodate their daily rhythms to each other, so that one day Content sits and watches chickens pecking in the dusty yard of a motel while O'Keeffe sleeps the morning away in her cabin. They have maps but do not seem to consult them much. The landscape interests them more, and the unchanging menus of roadside diners. Twice they take wrong turns and drive for hours back the way they came. They lose their way in rainstorms at night, and storms force them to take shelter during the day, once in a Ford agency. "G. had them all excited because she began looking at Fords and with the possibility of a sale they frothed with excitement."[24] Content also photographs. Near Colorado Springs, she tells Toomer, "I stopped by the side of the road…to take a picture which Georgia noticed. We set up a complex procedure and equipment to take it. I will call it a portrait of Georgia O'Keeffe."[25]

The picture has nothing to do with the way O'Keeffe looked or painted. Rather, it is the first picture of the journey in which Content resumes the style she had begun to fashion during the previous summers with Grant. It shows a bright field of grain beneath a blank sky; tonal values are so close together that only a thin, long, dark, and irregular line of a far-off train marks the horizon and differentiates between earth and sky. The delineation of space is precise, but Content's economy of means has become so stringent that the picture is much more abstract than almost anything she had done before and indeed achieves an abstract quality rare in American art of the time.

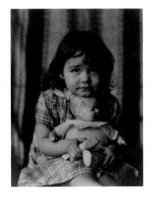

Her writing also shows a similar tendency toward precision of observation: "Georgia said…'Why should poplars against the sky look more beautiful [in New Mexico] than at Lake George?' Well, the sky here is quite unlike any eastern sky that I know of—The atmosphere that we see it through lends colors that one doesn't see except from high dry lands—and the red violet color of the earth reflects up, and tints the lower edges of the great white clouds,"[26] and a similar compression: "Everyone smiles more readily in these parts," she writes from Nebraska. "The easy western way & the wave of the hands."[27] A field is, simply, "furrows of brown earth against sky."[28] In the sky just before a storm, "Great masses of grey transparencies overlaid darker greys."[29]

On June 12 they reached Taos. "I have on a white dress," Content writes, "and am looking for a house—A house big enough to house someone over 6 ft.—It must be fixed so that it is an elastic house…"[30] They rent and fix up a small adobe house in the desert town

27

Fig. 14. *Margot ("Argie") Toomer, three years old, March 1935*

of Española, turn an abandoned shack in the hills into a studio, watch cowboys at work at a nearby ranch, go to town, find a lawyer for Content, work, and, sunbathing naked on their patio, discuss the relative manageability of their men. Content photographs landscapes for herself and Native American life for the Department of the Interior—her one commission—and continues to write almost daily letters to Toomer.

Her expressions of her love and need for him are frank and unforced and range from lovers' commonplaces—"My dear—my sweet. I wish you were here"[31]—to unself-conscious outbursts: "Mail-mail—that's what I want."[32] With lines like "How goes the work dear?",[33] she can imagine him as separate from herself. Yet by calling him her "base and apex"[34] she shows that her absorption of his ideas and vocabulary has begun.

By contrast, Toomer relates everything to himself. "I am going to write…to you, and then go up and make myself handsome by shaving, etc.," he says in his first letter to her.[35] Their getting lost is proof that even the car "didn't want to leave me!"[36] As for the base and apex, "The base of human life," he replies, "is a right relation between man and woman,"[37] and he figures himself at the apex of theirs. He praises Content from on high—"And so! Shelton, Neb. the second day! 420 miles! What kids you are, yea, great kids, world-riders!"[38]—and talks about her in the third person as though writing about someone else: "Yes, but she was just a Navigating Officer! She was just the skipper of a great ship! She brought the ship into port!"[39] Whereas her letters begin with calm expressions of love—"The morning has sped away, darling"—his begin in feverish baby talk: "You dear, tired woozy darling!" "Darling Kitten-Kat!" "You darling, you just darling bunny!" He calls her

and O'Keeffe "The Tough Girls,"[40] but when he is angry with her,
he condescends to her—"My dear child"—and tells his mother-in-law,
"'If I had them here…I'd spank them,' which I meant. Yes I did. And
then I said 'I'm going upstairs and write just a little letter, while the
feeling is hot, telling our Marjorie just how "some little slip" made me
feel.'"[41] The "little slip" was her failing to write to him one day. But,
he says, lest this was because of some accident,

> *I surely do not want to hurt you more…So I'm going to put a*
> *warning on the first page asking you…to defer reading these burning*
> *pages until you are better. Or, maybe I won't. Because there be*
> *energy in these pages - and this same said energy can enter you from*
> *these same said pages, and fill you full of - shall I say? pep?*
> *Youse, good wold [sic] PEP! O.K.!*[42]

His anger hurts her nonetheless, and her tearful reply reveals the extent
of her vulnerability:

> *Jean - Jean -…I'm damned if it isn't unfair———yes from beginning*
> *to end-*
>
> *All I can do is to sit here and drop drops of water out of my eyes like*
> *any idiot…*
>
> *Well—I'm not a writer—I can't tell you what I've been feeling———*
>
> *But please—darling—don't—oh don't do this to me again,———*
> *Say something to me when you're here———but let me get through this*
> *time of waiting and separation as best I may———*[43]

He forgives her, changes his mind, dismisses her explanations with
"You ought to be thoroughly ashamed…You, Marjorie, to give me, Jean,
such stuff,"[44] calls her writing unworthy of him, and moralizes:
"…you have been sleeping…as if you had kept yourself, half deliberately,
under an anesthetic."[45]

29

In Española Content soon lost her hold both on her new sense of form and on the concentrated gaze of her earlier style. Her photographs of Indian life and of ranch work are full of sharp observations of faces, gestures, and the bodies of men and animals, but most often these exist in weak or unresolved compositions.

As her divorce neared finalization, and Toomer's arrival approached, her letters turned entirely to practical matters. Content and Toomer were married in a festive, slipshod ceremony presided over by a drunken justice of the peace, which Content recalled with amusement in later life. But she wrote and said little about the remaining weeks with Toomer in New Mexico.

Back East, Content and Toomer and his daughter, Margot, lived at first on West 10th Street but moved in 1935 to a farm in Doylestown, Pennsylvania. There they raised Margot, worked the farm, began a philosophical press, and published a few pamphlets based on Toomer's ideas. A number of Toomer's disciples settled nearby, and a few moved into the farmhouse itself. Both the farm and the press lost money and were abandoned, and the family gradually began to live off Content's income. Marjorie kept house for Toomer and his friends, recorded their meetings, and absorbed Toomer's quest. In 1936, two years after their wedding, she wrote to Susan: "I have been doing some writing... to try to discover...the purpose of life, and...how to attain it. As you probably guessed, that is essentially what Jean's book is about...at last, I have become vitally interested on my own account."[46]

By contrast to the hundreds of pages on Toomer's themes, Content's written comments on art are sporadic and mostly platitudes. And no written statements about her work by her friends have been

preserved, apart from Stieglitz's "splendid" and this worthless comment from O'Keeffe: "The little print is lovely - really seems perfect - makes me want to kiss you quick."[47]

With no discourse about art and no ongoing definition of herself as an artist to fall back on, she had little defense either against Toomer's insistence that she join his quest or against the undermining sense that she was continuously failing him:

> I <u>want</u>...to <u>share</u> J's work...also I can see that this is...<u>the</u> way - Yet try as I may, I cannot...read on related subjects...and fall asleep with the book in my hand. J. has recommended writing. I have tried...but have not...touched off any spark...I would not be putting this down now - except that I think it will please J that I have done something today aside from gardening or housework.[48]

Echoing his harsh letter of June 1934, she wonders if something in her "died - or fell asleep - or atrophied" because "I did things" as a young woman "which were contrary to my values - and not only forgave myself for them - but wouldn't even face the facts to myself."[49] Later, she called this way of thinking

> spinning webs...I doubt its...validity - yet there must be something wrong...
> I do not even follow up the leads J gives me...have not gone to him to ask what he sees as my function in this work - in life...Why?[50]

In 1938, she finally began to see herself and Toomer simply as different personalities, yet she still wrote of him as her superior and apparently did not try to attribute these differences to his nature as a mystical writer and to hers as a visual artist concerned with the beauties of appearances.

Yet that she was a born artist there can be no doubt. Once awakened, her will to form expressed itself compulsively. When her

photography tapered off after her marriage, her creative impulse found
its outlet in writing and, occasionally, in drawing. Her letters and journals
from the late 1930s forward are full of quick, deft verbal descriptions and
occasional rapid, sure-handed drawings in a number of styles. Although
she regarded her journals as notes to be worked up later, they often read
not like writers' notes but like sketches for pictures. For example, with
scenes and events that are full of movement, she often creates still tab-
leaux, as in this passage on a religious procession in Calcutta in 1940:

> *The drums are very varied in tone, size & shape...The dancers*
> *also vary in size & shape!...Little boys...not over 5 yrs old. To middle*
> *aged men in groups...Elephants were large & small...some even*
> *electrically lighted like Xmas trees!...The whole procession was lighted*
> *with flares carried by men on long poles.*[51]

Human beings are largely still and almost always silent: "He was sort
of round and bouncy, had ferocious eyebrows, and everything else about
him reflected merriment."[52]

With landscapes, buildings, rooms, and objects, she character-
istically names a salient visual feature, as though imagining a picture and
jotting down its elements, such as color,

> *deep sky blue ceiling—walls of gold leaf—and wood work of Chinese*
> *vermilion*[53]

surface,

> *poisonous looking cakes and sweets—and glasses with aniline colored*
> *liquids topped with dry whipped cream*[54]

and variation, as in this description of Javanese waiters on a ship:

> *[They] wear turbans of the Javanese cotton goods—but the designs*
> *and textiles are far more varied and more beautiful than I've ever*
> *seen...and the ways of tying them vary also....I love to watch their*
> *faces. There are many different types.*[55]

She often combines the subject at hand with memories and thus transforms the world of appearances into the world of the imagination. Continuing on about the Javanese waiters, for example, she pictures them dressed like the Navajos she had photographed in New Mexico and so transforms waiters, Navajos, and her photographs into a new imaginative vision. Elsewhere she peoples landscapes, sees allegories in clouds, and recasts strangers as figures out of literature, art, and fairy-tale illustration.

The abundance of such passages in her writing suggests that Content was compelled to convert experience into fixed, clear, accessible form, and she states explicitly that she writes in order to fix experience not in memory but in "consciousness." And to her, consciousness was primarily visual. In a journal entry of March 16, 1938, she describes a recurring dream in which she holds "clear direct conversations with myself," but "As soon as I [try] to write [them] down… contact vanishes…" and adds that she finds thought itself "elusive," like "black specks…floating in the atmosphere….You see them out of focus from a corner of the eye…follow it, it goes completely from your field."[56] On the whole, her writings give us a woman who thought more in visual imagery and artists' technical terms than in concepts, abstractions, or even words.

Toomer was paradoxically a devoted and unfaithful husband, dependent upon Content and imperious, the wise teacher and the confused searcher. His search for his place in American letters, for spiritual truth, and for a following kept the household unsettled. "Under present conditions," an undated manuscript in Content's hand states:

33

> *there is no private life possible....One cannot do one's work...*
> *fruitless interruptions - & confusion reign. The friends (?) are*
> *contributing nothing. The whole relationship is lop-sided.*
> *Moreover, I say from <u>me</u> they are not invited and not welcome...*
> *I emerge from this exhausted.*

At the same time, attached to a page of this manuscript are two pages of pencil drawings, one of pots and vessels, the other of a flower.

In the late 1930s Content and Toomer became interested in Quakerism, the town of Doylestown being in the heart of one of the few centers of the unprogrammed branch of the Religious Society of Friends left in America, and they began attending the nearby Buckingham Meeting. They sailed for India in 1939 with Toomer's daughter, Margot, then six, Toomer in search of enlightenment, Content out of a need to help her husband find himself. Both efforts failed, as did Toomer's religious writing after their return in early 1940. Content was disillusioned, angry, exasperated. When her father died in 1941, Content told Toomer she was no longer either his disciple or his servant. They did not separate, but she lived her life essentially on her own.

She built a darkroom on the farm but photographed only sporadically. She became involved with the Buckingham Meeting, with the Buckingham Friends School, and with Doylestown's community theater as both an administrator and a character actor. And she gardened.

Toomer suffered numerous health problems—kidney failure, gall bladder, severe arthritis—which eventually rendered him an invalid. On May 13, 1964, during Toomer's final illness, Content set down the "scars on my spirit - soul" resulting from their marriage, including Toomer's having

> *invited his Wisconsin pals...to live on me....I served all these people...*

34

by gardening, picking all vegetables - preparing - cooking & cleaning
up - all one summer during which I hardly saw or spoke to him—
Yes, I slept with him - Then one evening...he called me a damn fool
because of some question I asked in front of a group of 10 or 12...

He posed as a sort of God to all....I think he thought sexual
intercourse an occasion for facetiousness. - Much later...he stole out
at night...& slept with one of his students...

Perfidious?...

Ever since he has been nothing but a...vegetable...Can't even
keep clean - Filthy pig Swine—limiting my movements to his "needs"
for about 8 - 9 years - [57]

Toomer entered a nursing home in 1960, and for several years
before his death in 1967 and afterward, Content helped with the trans-
fer of his papers to the archives of Fisk University, Nashville, Tennessee,
and gave accounts of his life to scholars.

She stayed in Doylestown, living in a renovated barn adjacent
to the original farm and with quarters for Susan, then for Susan's son,
Keith, and his wife, Nancy. Margot Toomer lived nearby with her own
children. Content then became active with the Doylestown Meeting
and supported social causes like prison reform. She continued to wear
simple but exotic clothes and to garden. Every autumn she would invite
friends to watch a night-blooming cereus flower. 35

Toward the end of her life, she told an interviewer that she had
had five professions and listed them in chronological order: a tutor for
a girl with eye trouble (when they were both in school); a partner in the
bookstore Sunwise Turn; a costume and prop maker for Theater Guild
and Neighborhood Playhouse; a photographer recording Apache life;
a wood worker and carver.[58]

NOTES

1. Letter, Alfred Stieglitz to Marjorie Content (MC), September 27, 1924; Alfred Stieglitz Collection, Yale Collection of American Literature, Beinecke Rare Book and Manuscript Library, Yale University.

2. Letter, MC to Kay Boyle, July 6, 1968; Content papers.

3. Ibid.

4. Thomas Lawson, *Friday the Thirteenth,* cited by Matthew Josephson in "Fifty Years of Wall Street," *New Yorker,* undated profile of Harry Content, probably 1938.

5. Josephson, op. cit.

6. MC to Kay Boyle, op. cit.

7. Interview with Flora Stieglitz Straus by Jill Quasha, Manhattan, January 9, 1992.

8. Interview with MC by Cynthia Kerman and Richard Eldridge, Doylestown, Pennsylvania, July 1978.

9. MC, journal entry, March 16, 1937, Content papers.

10. MC to Boyle, op. cit.

11. Clipping from unidentified Manhattan newspaper, 1919; Content papers.

12. Sandra Whipple Spanier, *Kay Boyle: Artist and Activist,* (Carbondale: Southern Illinois University Press, 1986), p. 10.

13. Kay Boyle and Robert McAlmon, *Being Geniuses Together,* (Garden City, NY: North Point Press, 1968), p.18.

14. MC to Boyle, op. cit.

15. Michael Carr to MC, undated illustrated notes, Content papers.

16. The Mowbray-Clarkes taught at Miss Finch's School. Arthur taught painting and Mary, English.

17. Content's work largely consists of contact prints from negatives ranging from $3\frac{1}{4}$-x-$4\frac{1}{4}$ to 5-x-7-inch negatives.

18. Although Content's lifelong friend Dorothy Obermeyer assumed it was Alfred Stieglitz who instructed her in the darkroom, it is more likely that Content perfected her darkroom skills with her friend, the photographer Consuelo Kanaga, with whom Stieglitz shared one of his formulas useful for gold toning prints. Interview with Barbara Millstein by Jill Quasha, Brooklyn, March 25, 1992.

19. Lawrence Durrell, *Wordsworth,* (Harmondsworth, England: Penguin, 1973), p. 11.

20. MC journal entry, Dec. 1, 1936, Content papers.

21. MC journal entry, March 29, 1937, Content papers.

22. Letter, Georgia O'Keeffe to MC, January 1934; Content papers.

23. MC, two-page loose-leaf typescript statement, May 13, 1964; Content papers.

24. MC to Jean Toomer (JT), June 9, 1934; James Weldon Johnson Collection, Yale Collection of American Literature,

Beinecke Rare Book and Manuscript Library, Yale University.

25. Ibid.

26. MC to JT, June 19, 1934; James Weldon Johnson Collection.

27. MC to JT, June 9, 1934, op. cit.

28. MC to JT, June 11, 1934, op. cit.

29. MC to JT, June 9, 1934, op. cit.

30. MC to JT, June 12, 1934, op. cit.

31. MC to JT, June 11, 1934, James Weldon Johnson Collection.

32. MC to JT, June 12, 1934, James Weldon Johnson Collection.

33. MC to JT, June 11, 1934, op. cit.

34. Ibid.

35. JT to MC, June 7, 1934, James Weldon Johnson Collection.

36. JT to MC, June 10, 1934, James Weldon Johnson Collection.

37. JT to MC, June 20, 1934, op. cit.

38. JT to MC, June 11, 1934, op. cit.

39. JT to MC, June 14, 1934, James Weldon Johnson Collection.

40. JT to MC, June 16, 15, 20, 11, 1934, James Weldon Johnson Collection.

41. JT to MC, June 13, 1934, James Weldon Johnson Collection.

42. Ibid.

43. MC to JT, June 23, 1934, James Weldon Johnson Collection.

44. JT to MC, June 19, 1934, James Weldon Johnson Collection.

45. JT to MC, June 20, 1934, James Weldon Johnson Collection.

46. Letter, MC to Susan Loeb, November 18, 1936; Content papers.

47. Undated letter, December 1933 or January 1934, Georgia O'Keeffe to MC, Content papers.

48. MC, journal entry, 1936/37, Content papers.

49. MC, Summer 1937, detatched manuscript in pencil on unlined paper, Content papers.

50. Ibid.

51. MC, journal of trip to India, 1939–40; p. 41, Content papers.

52. Ibid., p. 27.

53. Ibid., p. 21.

54. Ibid., p. 15.

55. Ibid., p. 33.

56. MC, journal entry, March 16, 1937.

57. MC, May 13, 1964; detached typescript.

58. Interview with MC, July 1978, op. cit.

No One I Know

The Mystery of Marjorie Content, Photographer

I myself am a question which is addressed to the world, and I must communicate my answer, for otherwise I am dependent on the world's answer.

—C. G. Jung, *Memories, Dreams, Reflections*

I Am a Question

Try to find her. It's not easy. She was a good dissembler, a convenient shade who emerges a minor character in the stories of others considered more important. She was the one called in to take Georgia O'Keeffe to Bermuda to recover from a breakdown. A biographer of Alfred Stieglitz describes Content as "sensible,…unexcitable,"[1] as if to reassure readers that during her convalescence, O'Keeffe was in good hands. O'Keeffe's biographers' descriptions of Content sound like personals ads: "a beautiful woman, black haired and dark-eyed,[2] with a gentle manner and an independent soul. She knew the Southwest and had worked for the Bureau of Indian Affairs, taking photographs of the Apache tribes in Arizona." "I like Marjorie very much," O'Keeffe wrote of her trip with Content to Bermuda, "and a place where the sun shines and it is warm—where no one will ask me how I feel and *no one I know* will be around seems very good to think of."[3]

Stieglitz and O'Keeffe had known Content since the late teens when she was married to Harold Loeb, a banker's son who in 1921 co-founded with Alfred Kreymborg and until 1924 published the important little vanguard magazine *Broom,* which printed the early works of Hart Crane, Guillaume Apollinaire, Gertrude Stein, William Carlos Williams, e. e. cummings, and Louis Aragon, among others. The New Yorkers in this generation formed a small, tight circle. Stieglitz's brother Leopold, a physician, "officiated"[4] at the home births of Content's two

children. Nonetheless, as the "thirty-eight-year-old divorcee and friend of the Stieglitz family" who accompanied O'Keeffe to Bermuda in 1933, Content served O'Keeffe as a requisite "no one." By all accounts her usefulness was her skill at making herself scarce so the painter could recover from what Stieglitz referred to as a "diabolical condition."[5]

Content was a "perfect companion." She was "cultured and cosmopolitan; she had many interests and knew everybody....She was warm, even motherly...yet tactful and discreet." Content was also literary and, from 1919 to 1921, helped manage a bookshop that doubled as a gathering place for the avant-garde "including those in the Stieglitz orbit." She "lived in a charming house on 10th Street. There, dressed in vivid flowing skirts and Indian jewelry that complimented her dark expressive features, she entertained friends from all areas of the arts." Pleasant, feminine, a student of the Southwest, she was an excellent friend for the painter, and muse for almost any artist when it suited her.[6] Content, "a sometime photographer,"[7] was "rich, well connected, and generous," and was thought by most who knew her to have, "no ambitions of her own."[8]

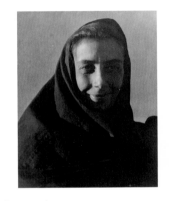

It is strange to hunt for a personality, a life, in the archives of others' lives, a task made more difficult by the absence of biographical exploration into the lives of women artists, especially those who kept their artistic passions a secret, even to themselves. Today, when we have only begun to tell the story of the vastness and intricacy of women's artistic efforts and the extent of their seclusion in the process, who would stop to take Content, the photographer, seriously, especially with

39

FIG. 15. *Marjorie Content, Taos, Summer 1933*

so little evidence that she did so herself?
We are still paying past debts of homage to
the women who stood up for themselves
and nonetheless were neglected by the
political machinations of the art world. But
what of this woman who was ambivalent
and silent about her gifts, especially when
it came to claiming arenas of her own

power, for whom attachment to a man was the primary requisite to
nurturing her own creative spirits? And when the man disappeared
through divorce or death, or besieged her with abuse, from frustration
or jealousy, what happened to her work, the energy, the desire to keep
the ideas flowing into visual form?

Content was always an encouragement to others rather than
taking herself seriously as an artist. We can hold this against her, but it
has little to do with the quality of the photographic work she left
behind, its artistic significance, or our peculiar response to it. There's an
odd disparity between the pretty, feminine, "rich, well connected"
companion, and the force of the visual intrigue produced by Content's
intimate camera.

40 Her photographic foray began around 1922, when she met
the British stage designer Michael Carr. At first, she may have used the
darkroom of Consuelo Kanaga, (plate 25) who had come to New York
in 1922 to work as a photojournalist, met Stieglitz, and remained there
until mid-1924.[9] Content's photographic activity tapered off around the
mid-1930s when she became enmeshed in a draining marriage to the

Fig. 16. *Paris, Winter 1931*
(courtesy of Timothy Baum, New York)

Harlem Renaissance poet and novelist Jean Toomer.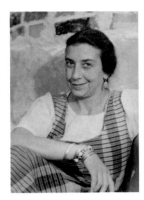
A fifteen-year period of strong work is brief for artists in
all media, except photography. In viewing photographic
art as a venture, a short-lived passion, many have fulfilled
the goals of a lifetime. But what was it to be a "some-
time photographer"? What can be said of work done
as an attempt, work hardly published, never exhibited,
work virtually forgotten, rarely referred to by the
photographer? The pictures are all we have to confront the ambivalence
of Content. But are they sufficient to rescue this devoted friend of
the famous from future misunderstanding? Those who knew her best
not only testify that she never claimed to be an artist but also appear to
believe her. Her success at mystifying her friends need not be held
against her, for her best pictures' consistent, intimate beauty shows she
was not ambivalent while making them. Content's incertitude seems
to lie in her chronic self-criticism.

 That she did not destroy the work or allow it to be lost is
itself a gesture toward self-preservation. She may not have known how
to regard her little pictures. Despite Stieglitz's supreme effort to grant
to photography all the expressive capacities of other media, Content
may not have believed that her own photographs could hold a candle to
the literature, theater, and painting that she had seen practiced by the
best living American artists of her day. It has always been the potential
role of viewers to affirm, and through this affirmation to preserve.
Those of us examining her photographs today become Content's muses
posthumously.

41

Fig. 17. *Marjorie Content,
Summer 1934*

*We allow the images to rise up, and maybe we wonder about them, but that is all.
We do not take the trouble to understand them, let alone draw ethical conclusions
from them....Not to do so...produces dangerous effects which are destructive
not only to others but even to the knower...and imposes a painful fragmentari-
ness on his life.* —C. G. JUNG, *Memories, Dreams, Reflections*

IMAGES RISE UP

When Jean Toomer got impatient with Content, he'd tell her
to work on her soul. What did this strange, selfish man feel was soulless
in his wife? Toomer had no interest in her photographs. Where photo-
graphy was concerned, Toomer deigned to look, but his responses
were those of a toady among the famous. In an essay called "The Hill,"
he rhapsodized that Stieglitz was "a man in his world," "solid in today,"
adding that "it is rare to find anyone in whom the two attitudes—
'I will,' 'Thy will be done'—are so balanced." When Toomer considered
Stieglitz's photographs, he saw "a genius of what is," and felt the palpa-
ble physical world as a realization that led to adulation:

> The *treeness* of a tree...what bark is...what a leaf is...the *woodness*
> of wood...a telephone pole...the *stoneness* of stone...a city building
> ...a New York skyscraper...a horse...a wagon...an old man...a cloud,
> the sun, unending space beyond...the *fleshness* of human flesh...what
> a face is...what a hand, an arm, a limb is...the amazing beauty of
> a human being...the equally amazing revelation of the gargoyle that
> hides in all of us but which he and his camera devastatingly see....[10]

Toomer was unable to acknowledge the same ambitions in pictures
by his wife. Had he opened himself to her work, he might have realized
that she was making subtler visual distinctions than those which sent
him singing praises to Stieglitz. In her modest photographic oeuvre,

Content made significant personal choices of
subject matter from her surroundings. She
imbued the merely physical with a conscious-
ness of the "subtle body" of a place or thing.
I would venture to say that this consciousness
emerges almost without her knowing it, in
no linear order, silently and gradually.

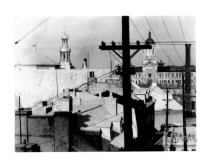

 At first glance, many of Content's pictures seem to embody
the modernist principles of art and design that dominated the avant-garde
internationally during the 1920s. Look at her view of Kansas in 1934
(plate 72) in which segmented rows of tiny railroad cars paralleling four
rows of barbed wire are exquisite in their minimalism. Her celebration
of urban forms—the spider's web of clotheslines in lyrical rhythms
against telephone poles seen from Doctors Hospital in 1933 (plate 19),[11]
or of Quebec segmented through telephone poles in 1937 (plates 47, 48;
fig. 18), as well as the languidly erotic flower studies—show her absorp-
tion and comprehension of Stieglitz-O'Keeffe principles.

 From her first real interest in the camera in the 1920s,
she explored the new unities between art and technology that László
Moholy-Nagy, Germaine Krull, Albert Renger-Patzsch, and others had
been proclaiming in Germany. In 1928, Renger-Patzsch published
Die Welt ist Schön (The World is Beautiful), a collection of one hundred
photographs that viewed the natural and industrial world with such
intensity that all things, a foxglove, a cup of coffee, a ferris wheel, even
a pair of human hands posed in imitation of Dürer's drawing of praying
hands, were rendered as diagrams of a universe conceived not by God
but by what the Bauhaus artists regarded as an even higher compliment,

43

Fig. 18. *Quebec, October 1937*
(collection of Anne Kennedy Nadin, New York)

modern recognition and creation of intelligent design.

That same year Content also explored the mythos of mecha-
nization in a line of sight that attributed to a pattern of piano wires a
kind of destiny (plate 11). Her photographs of machine-made cigarettes
in their pack or piled on a tray (plates 13, 16) or chess pieces arranged
on a board (plate 12) project a feeling of formal authority that acknowl-
edged "Light," as Moholy, in 1923, entitled his article in *Broom*, "as a
Medium of Plastic Expression."

She used light as an element with which to build pictures and
took photographs from vantage points characteristic of Moholy, Kertész,
and other Europeans. Moholy loved to look down, as if from an airplane,
or a modern apartment building, or a radio tower, in order to reduce
a human being to the mere contour of his hat or dematerialize him into
his shadow. As Kertész did later, Content, from her New York apartment
window around 1928, surveyed Washington Square and similarly plotted
urban territories into pleasing geometries. As opposed to Moholy's
witty visual tricks, hers was a transformation of the street into a kind of
interior, with its furniture of manhole covers and a parked car that
cozies up to a street lamp (plate 1). In spring she chose moments when
the sidewalk was laced with shadowgraphs of foliage (plate 3); the straw
boater worn by a man on the park bench jumps away like the more
notorious boater in Stieglitz's *Steerage* of 1907 (plate 5).

Content's choices of shadow foliage, to mollify the angularity
of the modern street, state her position vis-à-vis a cubistic Bauhaus
frame of mind. Moholy's cameraless photograms, which plotted pure
light and shade, testify to his respect for the pictorial integrity of shadow
patterns as stand-ins for physical objects. And Kertész, photographing

the stairs of Montmartre, or the chairs at the Medici Fountain in the
Luxembourg Gardens, in 1926, had beautifully orchestrated lyrical shad-
ow skeletons as counterparts to urban furnishings of chairs and railings.[12]
As with all photographers whose work is memorable, there is the sense
that we are returning to the most elemental language of photography
in its first moments.

Content followed this reexamination of shadows with the
same dedication, but in her own way. As William Henry Fox Talbot
showed, in his photogenic drawings of the 1830s, an object can be
connoted through the contours of its silhouette. Such elemental poetry,
something not learned but seized through intuition, never explains
but recalls. In another downward view of Washington Square (plate 7),
Content fixes on the pattern of a leafless winter tree, the branches of
which seem to dance on the sidewalk below. This recurs in 1932 in
the view she made of a church in Connecticut (plate 46) and in
1933 when she photographed another tree in her friend Mary Hamlin's
courtyard (plate 8). With these images, it is easy to think of Talbot's
romance with the animated tracery of trees on his estate of Lacock
Abbey in the 1830s and 1840s. Like Talbot, Content discovered the
mystery of telling.

Moholy's theories of photography in the 1920s were based
on a rudimentary knowledge of the history of photography, which at the
time hardly existed. His conception of a vision determined strictly by
the lens and camera box called attention to the basic principles of
photographic seeing as a creative reformulation of how to make pictures
with a box. His aim was to define camera work as clearly distinguishable
from all other media, an approach that differed from many American

pictorialists who had sought to validate photography through its power to imitate other arts with a longer tradition.

This awareness of photography's mechanistic purity also sought to convey the very soul of each subject genre. The ubiquitous portrait head dominated the first daguerreotypists' mania to record and identify a rising middle class. Moholy regarded the portrait head not as an occasion for resemblance; instead he saw the head as a sculptural "modulator," which, seen up close, simply collided with light. The photographic

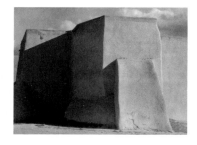

portrait, for Moholy, was to be a record of this collision. Content's earliest serious pictures, from 1926, framed the heads of Helen Herendeen (plate 22) and Bruce Christen (plate 15) so tightly as to virtually cut them off. And in 1929 Content photographed Marsden Hartley (plate 24) with a similar intention of reconstituting him in light and shade. By using an up-close framing device, along with light that fairly fractures old representational formulas of expressive human demeanor, she conveys an explosive emotional presence, further intensified by the picture's small scale of 3¼ by 4¼ inches.

With the same concern to extract new meanings from time-worn subject matter, in 1932 Content, almost perversely, decided to photograph the Grand Canyon in the same small format. She did not try to replicate the site into a precious miniature; instead she rendered the place into a fine membrane, a gossamer that intensifies the always breathtaking experience of the site's spatial incomprehensibility. These pictures grant an aura of tentativeness and uncertainty to the Grand

46

Fig. 19. *Ranchos de Taos Church, Summer 1932*

Canyon's classic durability, creating a kind of tension
that makes her little pocket views virtually palpitate
(plates 62, 63, 64, 65). Moholy favored such visionary
transformations in his own photographs of the early
1920s. He called them "transparent" to distinguish them
from mere resemblance.[13]

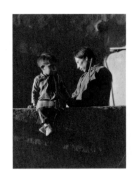

Traveling in the Southwest during two summers
in the early 1930s, Content discovered an abundance
of subjects through which she could explore this trans-
parency and move her work beyond the realm of
description into that of symbol. As a self-styled ethnogra-
pher, in 1933 and 1934, she photographed Navajos in
Shonto and in Red Lake in northern Arizona (plates 58,

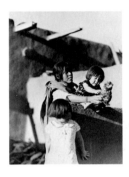

59, 60, 61) and Taos Pueblo Indians in northern New
Mexico (plates 51, 55, 57; figs. 20, 21) who had become her friends.
She saw them as durable shadows, static emblems, which declare the
persistence of a people who had set themselves apart from a world that
continually threatened to annihilate them.

She fixed on subjects that lent themselves to symbolic interpre-
tations rather than those that were generally understood. At O'Keeffe's
house at the Ghost Ranch, Content waited for the dying light to turn
the facade into a grotesque gothic letter (plate 49). Her view of the
Canyon de Chelly in 1932 echoes this strategy to extract linguistic signs
(plate 67), as does her photograph of a rock form in Blue Canyon made
that same summer (plate 70). She simplified the apse of the infamous
church of Saint Francis of Assisi at Ranchos de Taos into one great

47

Fig. 20. *Adam Trujillo and his son, Taos, Summer 1933*
Fig. 21. *Maria Trujillo with her children, Taos, Summer 1933*

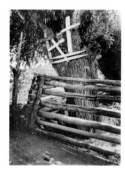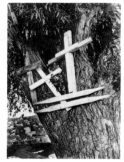

shadow that all but obliterates the
adobe's almost obscene fleshiness;
the contour she waited for cuts into the
side of the church like a knife cutting
fat (fig. 19). In Taos, her vantage point
on wild plums drying on a rooftop
reads like a survey of unknown territory
(plate 56); bread ovens that she deprives of any daily or celebratory
ritual conjure the very womb (plate 69) of ancient New World civiliza-
tion. Ordinary wooden slats nailed to a tree seen from a distance are
merely picturesque (fig. 22); close up they become a puzzling riddle
(fig. 23). Standing back from an arrangement of kachinas, Content
drains them of their sculptural form. Instead she presents an animated
silhouette, but one without charm. We confront a sort of pictographic
wall that signifies an arena of power and warns those who might
approach. Content grasps the meaning of the kachina (plate 52). In all
of these pictures she penetrates resemblances and enters the subtle body
of the physical. She lets appearances provide the stimulus, to which she
responds reflexively, thereby inventing new meanings for what could
easily be regarded as merely seen.

48

Throughout her photographs,
every chosen subject is some version of
Renger-Patzsch's "beautiful world." From
1928 to 1935, she paid homage to revered
figures who were her bookstore colleagues,
such as Lola Ridge, assistant editor of
Broom, in portraits (plates 30, 68; fig. 24)

Figs. 22 & 23. *Talpa Road, Taos, Summer 1933* Fig. 24. *Lola Ridge, 1935*

that are classic in the literary self-consciousness of sitter and author. Content's cloud studies of 1928 and 1941 also maintain this beautiful world in American terms in the abstract musical "correspondences" that Stieglitz strived for in the series of "Equivalents" (plates 41, 42). As with many of her contemporaries, all seems worthy of her lens.

She veritably illustrates Toomer's accolades to Stieglitz by showing "a city building," "the woodness of wood," "what a face is...what a hand, an arm, a limb is," "the sun, unending space beyond...." But her visual imagination, especially through its self-deprecation and modesty, seems to allow her to penetrate to the unfamiliar soul of the object. In scrutinizing a branch overtaken by tent caterpillars (plate 45), she is attracted to the natural grotesque, or as Toomer expressed it of Stieglitz's work, to "the...amazing revelation of the gargoyle that hides in all of us."

Quietly Eating In and Around

Content's legacy to photography lies in the subtlety she discovered, perhaps unconsciously, about its power to elicit deep responses beyond mere resemblance. Her work was not an explication of Bauhaus theory. Nor was she willing to become the adoring Stieglitz follower. She was far from the mesmerized Stieglitz student that, for example, Dorothy Norman was. The pictures by Norman that Stieglitz regarded as "wonderfully felt" he would initial in a letter code ILY (I Love You) or IBO (I Bow Out), by which the master meant that Norman had achieved her intentions; and he bowed to her success.[14]

By comparison, Marjorie, reputedly incapable of anything imaginative without the impetus of a love affair or a marriage, was a

49

photographic loner, a trailblazer from within. In relative isolation she moved beyond "wonderfully felt" effects to explorations of the tentative in appearances. Her best pictures express the contradictions in what lies hidden, with light that not only reconstructs but quietly eats around and into a thing.

Content's studies of plants and flowers lead to the worm in the rose. Recall the tent caterpillars. A sheaf of corn is lens-faithful in the manner of Renger-Patzsch, but her choice of dark background transforms it from the Bauhaus's love affair with form for form's sake into something uncommon (plate 50). Looking at the uncurling fronds of ferns (plate 36), she stands just far enough away so that they are rendered strange. She views a jade plant so closely that it looks alien (plate 23). In a view of growing things that refuses to confer on them any relation to origin, she does not present pussywillows as part of a plant, but more literally she suggests something of the plant's significa-tion. In the opaque blackness against which she grasps the little fur heads bobbing disembodied and unfocused, they become as strange as a pet attached to a stem (plate 40). It is not surprising that she photo-graphed Paris in a winter rain in 1931 (plate 2) from a high vantage point with the same disregard for conventional syntax of space. Nor did she feel the need to fulfill expectations of a place, so that the result is as inconclusive as a shadowy photogram by Moholy.

In the realm of flowers: did the tropical anthurium merely represent art-deco taste to rich well-connected New Yorkers in the 1920s? Or did it allow Content to pursue what seems like a consistent predilection for hidden allusions? She backlights the anthurium's leathery petals, bold stamen, and silhouetted stalk to make it look as

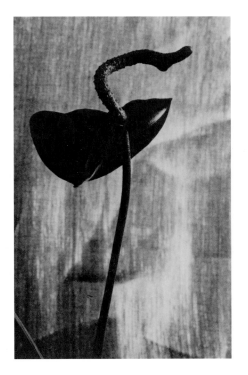

Fig. 25. *Anthurium, c. 1931*

uncomfortable as a flower could be (fig. 25). No one photographed
flowers like this at the time. Content fixes on the excited, crooked stamen
as a grotesque appendage against the light. Like the new meanings
granted to the kachinas in New Mexico, the anthurium's power comes
from its seeming like a strange calligraphy. We are made to consider
language. Did she know that in Greek *anthurium's* middle syllable means
"tail"? And that in New Latin the word means "flower tail"? (plate 10).

The calla lily, another tropical, reigns supreme in the photo-
graphs of Content. She idealizes its showy white spathe by lighting
it as if for a fashion sitting. But beyond drawing out contours of white
light in what is clearly an attraction to the flower's stylishness (plates 14,
29, 35), she has the spathe wrap around the yellow spadix like an
enclosing shell. The philosopher Gaston Bachelard in his discussion of
shells in *The Poetics of Space* cites many such enclosing images that
espouse dormancy. "A man, an animal, an almond all find maximum
repose in a shell," Bachelard writes.[15] In Content's callas the virtues of
repose also dominate. That Edward Weston and Imogen Cunningham
were exploring the same interconnectedness between enclosing
organisms and those of the intimate human body seems to have been
unknown to her. Undeniably, Content felt O'Keeffe's impetus to exam-
ine flowers close up. And like the painter, she probably would have
denied any explicit connection between flowers and sexuality.

Nevertheless, a poetics of internal spaces may be explored at
some length in Content's flowers, which seem in the small scale of the
images to mediate between intimate anatomies. It is not surprising
to find structural affinities between an amaryllis bud opening its petals
(plate 38), or one viewed to show a petal's veins fanning out in a near

gesture through transmitted light (plate 4) and the outstretched arms
of the absorbed reader Edward Bright, whom Content finds lying like a
field flower in the grass (plate 39).

In a self-portrait from around 1928, Content's remarkable
positioning of her own hands (plate 26) grants to them a state of floral
emergence. She presses one hand back unnaturally, as if to rob it of its
usefulness. The other hand rests on and toys with this hand at the
same time. Content's eyes avert our glance, even while her mouth
sculpts a social smile. But it's the hands she wants to act as her portrait.
Hands on stems open like petals of an amaryllis (plate 9) or a water
lily (plate 28).

Content mediates often between the secrets of floral unfolding
and psychic emergence. Take the girl on the threshold of womanhood
explored in the studies of her daughter, Susan Loeb, from 1930. At this
time Susan, born in 1916, was an adolescent. In a view of the girl's
thighs (plate 31; and front cover), perhaps one of the most sensual pho-
tographs made by one woman of another at this time (not discounting
even Cunningham's investigations of flower anatomies and nudes in
California), the girl's left hand reaches around to grasp her knee and calf.
The structure is again organic, allowing the image to resonate beyond its
human source. The space between the figure's legs is lodged firmly along
the lower edge of the frame. We don't see the sexual anatomy, but we
know it is there, for the bottom of the frame underscores, even while
it conceals, this privacy. The petal-like hand reaching along the leg suffi-
ciently defines the budding flower of the girl. By the same token, two
soft-focus studies of Susan's face are shot like the calla lilies, as studies of
sexual latency (plates 33, 34). And the view of Susan holding a fruit and

53

glancing into it as if into a crystal ball connotes the promise we feel in
early spring gardens when all is still possibility (plate 32).

Perhaps this is why the vines in Content's little portrait of Jean
Toomer with Chaunce Dupee in Portage, Wisconsin, in the summer of
1934, just before her marriage to the poet, are so touching (plate 37).
They signify a promise of happiness that we plainly see does not exist in
the stark contrast between Dupee's cheerful grin and the evasive body
language of Toomer, the fiancé, who all but resists portrayal. The flowers
around the figures ironically question the happy bower that garlands not
the engaged couple, but a reluctant partner in a doomed alliance.

With Content we travel in the secret halls of allusion. Hers is
the work of a poet, for the modest pictures have a subtlety that seems,
at times, to precede description. Ever open to connection and recon-
nection, they never declare or explain. Her voice feels like that of
the poets of the late Tang, such as Li-Shang-Yin (812?–858). In the most
subtle use of allusion, each line is exquisitely sensitive and encourages
a state of contemplation. In Li-Shang-Yin's metaphorical complexity,
"one scarcely meets a simile":

> *Each flower spoils in the failing East wind.*
> *Spring's silkworms wind till death their heart's threads:*
> *The wick of the candle turns to ash before its tears dry.*
> *Morning mirror's only care, a change at her cloudy temples:*
> *Saying over a poem in the night, does she sense the chill in the moonbeams?*
> *Not far, from here to Fairy Hill.*
> *Bluebird, be quick now, spy me out the road.*[16]

Content's difference from her female contemporaries
lies within this poetic sensibility. Recently published monographs on
Dorothy Norman and Consuelo Kanaga permit us to reflect on the

three photographers' differing ambitions in the context of the many subject categories they shared.[17]

Norman's portraits are those of veneration. When she diverts from this aim with her nude study *Catherine Bauer, Woods Hole*, c. 1932,[18] it is two years after Content's exploration of the arm and legs of her daughter, discussed above (plate 31; and front cover). Norman's effect is a lesson in juxtaposed fragments and differs greatly from Content's capacity to treat the body as if it were being created in a primal fluid, as if it had no known origin in time but existed in a mysterious process of emergence. This sense of incompleteness prevents Content's pictures from being merely attractive. Their lack of closure is the very quality that helps us to distinguish her superior gifts.

With the work of Kanaga, the situation is even more interesting, for Kanaga's ambition throughout her career to portray the human social condition grants her work clear authority. Her success as an artist stems from her political aims. She consistently revealed the beauty of the physiognomy of ordinary black people, and perhaps of all photographers, besides Doris Ulmann, during the first half of the twentieth century, she was the most successful in achieving this.

Content's authority as an artist has no such agenda. She worked with less. It is exactly this departure from a documentary intention that gives her pictures more intrigue and depth. Hers is the amateur's path, the path of the uncertain seeker. Photography, from the beginning, has attracted such private sensibilities who had nothing to prove, no ideas to explicate, except what might be extracted from the way light touches the here and now and leads our imaginations into the realms of recollection.

55

An Atmosphere of Permission.

The pictures tell much. They are all we need. But our purpose here is not only to appreciate a visual achievement but to reflect on the circumstances that made it possible for a particular woman in the 1920s to consider working imaginatively. As Content's posthumous muses, we are not only excavating a box of beautiful pictures left behind, we are seeking the forces that drove forward a sheltered New York City girl who until the late teens had "never traveled below 14th Street."[19]

Content's daughter observed many years later, not without some chagrin, that her mother's personality was utterly "dependent on whom she was doting on at the moment."[20] It would be easy to let a statement like this become an indictment. But for certain talented women without the inner courage to exploit their gifts, a man represented a choice, not only of a way of life but an opportunity for thinking and for awakening what lay sleeping within the creative self. There were four husbands: Loeb, Carr, Fleischman, and Toomer. All represent stabs in the direction of self-fulfillment. Three were errors of judgment. Yet as we seek to resurrect Content through her images, we have to accept all the usual excuses of a woman who felt she could escape and even grow through submission.

Little in Content's life as an "encouragement" to others seems to have prepared her for the process of poetic visual thinking so explicit in her photographs. Despite the impact of Bauhaus ingenuity on many creative talents in the 1920s, there is no clear line of teachers or influences that might characterize a more regular artistic development.

Fig. 26. *Michael Carr, Summer 1923*

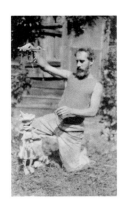

Instead one sees influences that granted a young, unfulfilled
woman an atmosphere of *laissez-passer* that allowed her to
sense her own creative possibilities even before becoming a
photographer. As someone capable of drawing exquisite
poetic meaning from the physical world, she realized in her
little pictures something concrete that she could call her
own. As we have seen, this became a feeling for something imperceptibly
fragile, dormant, and above all intimate.

It is important to recall that her picking up the camera around
1922 came about with the arrival in her sphere of a startling character,
second in her string of remarkably individual husbands and companions.
This was the British theatrical designer Michael Carr. From
the beginning of their association, Carr threw her into pre-
posterous situations. In a sense, he taught her to dive before
she believed she could swim. Although she had never made
a costume in her life, he had her assist him and collaborate.
She overheard him bragging on the telephone that "Miss
Content designs all my costumes" and found herself, incred-
ulously, with a staff of seamstresses; soon her costumes

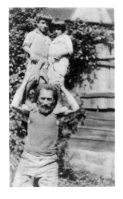

were appearing in fashion and theatrical magazines. Life was a sponta-
neous game. For a play called *The Miracle,* in which the regular costume
designer had suffered a breakdown, Content found herself suddenly
in charge, tearing apart back-row seats of the theater for necessary fab-
ric to make new costumes on the spot."[21]

Also, soon after they met, Carr and she were designing and
hand-building a fieldstone house in New City. When she photographed
this process and showed the pictures to Stieglitz, the photographer

Fig. 27. *Michael Carr, Summer 1922*
Fig. 28. *Michael Carr with Jim and Susan Loeb, Summer 1922*

called them "splendid." Today these very ordinary, faded snapshots reveal nothing of what could have been on Stieglitz's mind. But it is not Stieglitz from whom she learned photography. "Oh no," she recalled, "his personality was too explosive. He wouldn't lower himself to it."[22] Such a statement reveals the difference between Stieglitz and the world of creative experimentation, without judgment, nurtured by Carr.

She said that at first she occupied herself with portraits. This might have been a way of indicating modestly that she had, like many wives and mothers, simply focused on her loving circle, such as Jim and Susan, her son and daughter by Harold Loeb, and then Carr (plates 31–34; figs. 1, 6–8, 26–28, 30, 31). She photographed the stone house because Carr, who became her husband in 1924, was building it.

Three snapshots from 1922 and 1923 that include Carr reveal an atmosphere of permission in which the photographer's latent capacities and confidence to act were given complete freedom. How different this is from the atmosphere of judgment imposed by Stieglitz. At The Sunwise Turn bookstore, Content, the bookkeeper, gave free books to starving writers from a private fund. She was happy to play the muse. Here, photographing Carr, she portrays *her own* muse.

Content's snapshots of Carr from 1922 and 1923 show the designer at age forty-five looking twenty years younger, a lean, ageless Pan with a sculpted body. As an artist for the theater, he also designed sets and puppets for avant-garde houses and the Broadway stage. In Content's photographs his presence in the sunny garden feels incandescent. In one shot he kneels down next to a puppet that he holds upright on strings (fig. 27); in another he poses with a cigarette (fig. 26). But in a third he has hoisted Content's two children onto his shoulders

(fig. 28). He is smiling, but their expressions suggest that they are so
unused to this gesture which makes them light, seemingly triumphant,
capable of flight, that they fix hauntingly on the lens. Their stiff little
bodies are so unengaged in Carr's exalted spirit that they might have
been pasted onto the image. Content's little New York City children
throw glances at their mother, as if asking her to explain the man to
them. Airborne, the children might have mirrored Content herself.
The man is new; he doesn't fit the categories she understands. From his
smiling face, a glow of openness says yes. All is go-ahead, permission
to soar and expand beyond what seems possible. "He told me I could do
anything. So I believed him," she remembered.[23]

A year before Carr's death Content began dating her first serious
photographs, which she took with a 3¼-x-4¼-inch Graflex. Her five-year
intimacy with Carr, who died in 1927, led to her setting up a darkroom
in her home the same year. After Carr's death, "again I was adrift," she
wrote. Then she started to study photography and wanted "to get away
from New York" and decided to "Go West." In 1932, en route to Colorado,
Content made a portrait of her traveling companion, the young painter
Gordon Grant (plate 71), who, she said, "introduced me to Indians."[24]
Grant sits in the front seat of an automobile. He looks sideways and leans
on his hand. At first, we don't see it, because the dusty windshield
has given his face a soft pictorial glow, but there is another figure super-
imposed on his form. It is the head and raised hand of his photographer,
a soft silhouette of a picturemaking gesture that is clear and confident,
decisively emergent against the face of the dreaming man.

NOTES

1. Sue Davidson Lowe, *Stieglitz: A Memoir / Biography* (New York: Farrar Straus Giroux, 1983), p. 325.

2. Although it has been disputed, her eyes were brown.

3. Roxana Robinson, *Georgia O'Keeffe: A Life* (New York: Harper and Row, 1989), p. 390. Present author's italics.

4. The expression is Content's in an unpublished letter to Harold Loeb from Mill House in Doylestown, Pennsylvania, January 11, 1954. A copy of the letter is in the Content papers, Doylestown, Pennsylvania.

5. Laurie Lisle, *Portrait of an Artist: A Biography of Georgia O'Keeffe* (New York: Seaview Books, 1980), p. 208.

6. Benita Eisler, *O'Keeffe & Stieglitz: An American Romance,* (New York: Doubleday, 1991), p. 439.

7. Ibid.

8. Ibid., p. 449.

9. Barbara Head Millstein and Sarah M. Lowe, *Consuelo Kanaga: An American Photographer* (Brooklyn: The Brooklyn Museum in association with Seattle: University of Washington Press, 1992), "Chronology," p. 205. Plate 41 of this monograph mistakenly identifies *Portrait of a Woman* as *M. C.* (Marjorie Content), when in fact it depicts Lola Ridge (see fig. 24 herein), and erroneously gives plate 68 of Native American women with wooden poles, dated to the 1950s to Kanaga, when in fact it was made by Content in the summer of 1933 (see plate 59 herein).

10. From *America and Alfred Stieglitz, A Collective Portrait* (Millerton, New York: Aperture, 1979), pp. 144–45 (reprint of the original of 1934).

11. See also illus. 46A.

12. See Sandra S. Phillips, David Travis, and Weston J. Naef, *André Kertész: of Paris and New York* (Chicago: The Art Institute of Chicago, 1985), which illustrates these two images on pp. 134–35.

13. Eleanor M. Hight, *Moholy-Nagy: Photography and Film in Weimar Germany* (Wellesley, Massachusetts: Wellesley College Museum, 1985–86), p. 21.

14. Miles Barth, ed., *Intimate Visions: The Photographs of Dorothy Norman* (San Francisco: Chronicle Books, 1993), pp. 29–30.

15. Gaston Bachelard, *The Poetics of Space*, trans. Maria Jolas (Boston: Beacon Press, 1969), pp. 124–25.

16. Fragment of "Untitled Poem," vi, from *Poems of the Late*

T'ang, trans. and with an intro. by A. C. Graham (New York: Penguin, 1965), pp. 143, 150.

17. See notes 9 and 14.

18. Dorothy Norman, *Catherine Bauer, Woods Hole,* c. 1932.

19. From the Content papers, Doylestown, Pennsylvania.

20. Report of conversation between Content's daughter, Susan Sandberg, and Jill Quasha, Doylestown, Pennsylvania, summer 1993.

21. Interview with Marjorie Content by Cynthia Kerman and Richard Eldridge, Doylestown, Pennsylvania, August 26, 1981.

22. From the Content papers, Doylestown, Pennsylvania. Stieglitz's role in actually encouraging Content's photography remains difficult to understand, much less to plot chronologically. Over the years with various friends, Content recalled different moments of contact with Stieglitz but did not give dates.

For example, she told a researcher on Jean Toomer, Alexandra Kizinski Babione, with whom she spent the summer of 1969, that during the period when she first visited Stieglitz's studio and first looked at his pictures (this could have been during the late teens), "He swooped me up, danced me across the floor, and persuaded me to do photography" (telephone conversation between Jill Quasha and Mrs. Babione, July 12, 1992). The publisher Nicholas Callaway, who knew Content in the early 1980s, remembers her saying that it was Stieglitz who taught her how to print (conversation between Jill Quasha, and Nicholas Callaway, June 1981). And Content told Cynthia Kerman and Richard Eldridge during an interview in Doylestown, Pennsylvania, in July 1978, "Stieglitz encouraged me, but at a distance."

23. Interview with Marjorie Content, August 26, 1981, op. cit.

24. From a brief account of her life written to Joan Stack and "sparked by your request for an interview." Typescript in the Content papers, Doylestown, Pennsylvania.

61

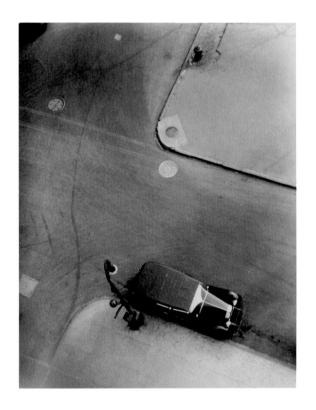

63

1. From Washington Square, New York, c. 1928

2. Paris—Rain, Winter 1931

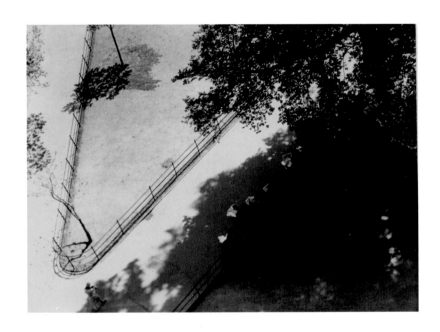

65

3. Washington Square, New York, c. 1928

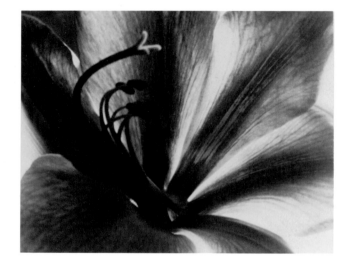

4. Amaryllis, 1931

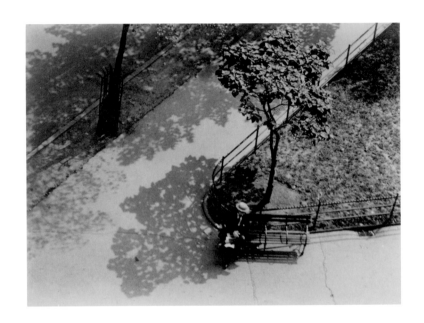

5. Washington Square, New York, c. 1928

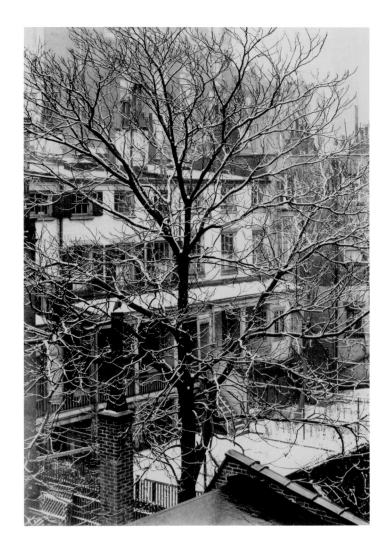

6. Backyard, 39 West 10th Street, New York, 1931

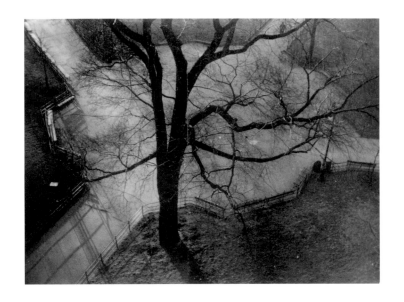

7. Washington Square, New York, c. 1928

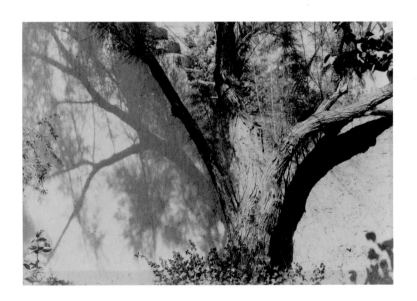

8. Mary Hamlin's Courtyard, Taos, Summer 1933

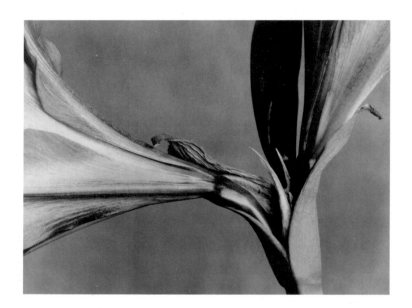

74

9. Amaryllis, 1931

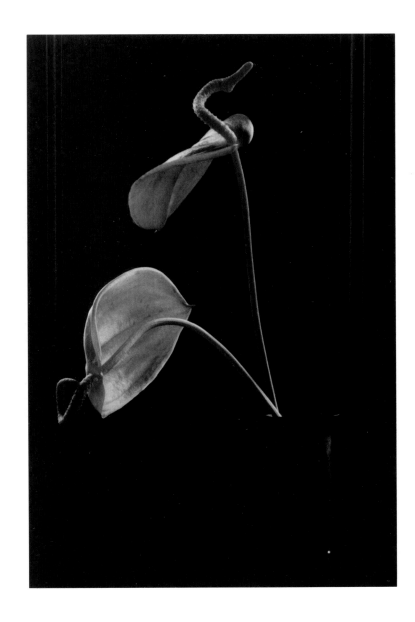

10. Anthurium in Vase, 1931

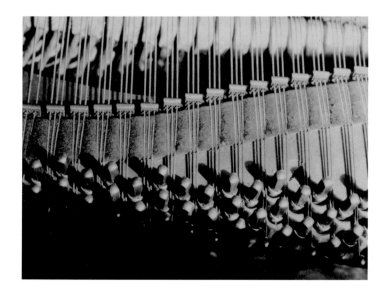

11. Piano Strings, c. 1928

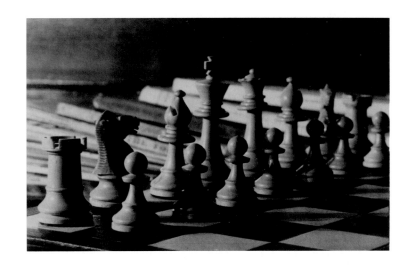

12. Chess Pieces, c. 1928

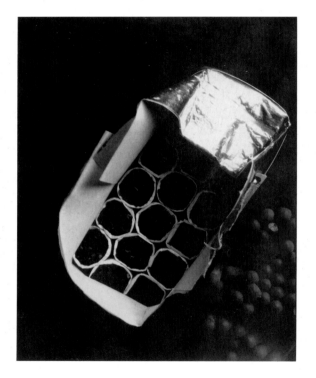

78

13. Cigarette Pack with Matches, c. 1928

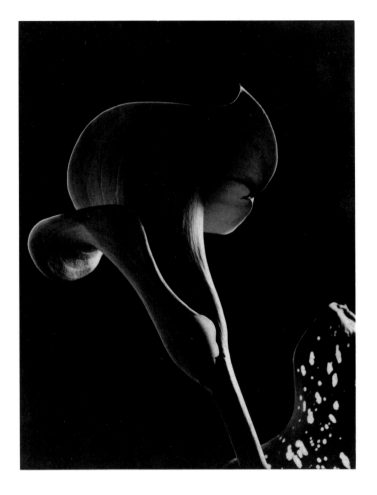

14. Calla Lily and Leaf, 1931

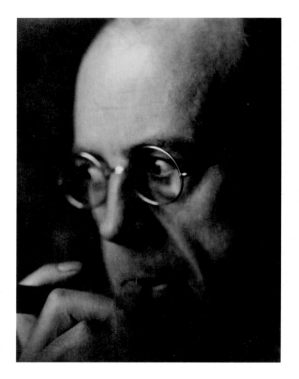

15. Bruce Christen, c. 1926

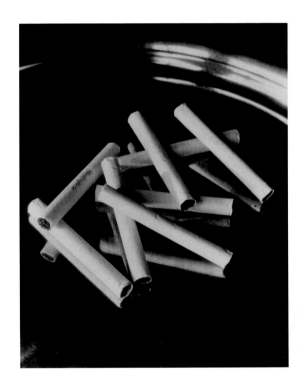

16. Cigarettes on Tray, c. 1928

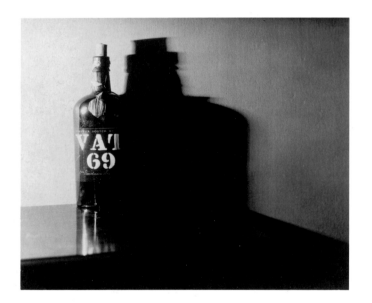

17. Vat 69, c. 1928

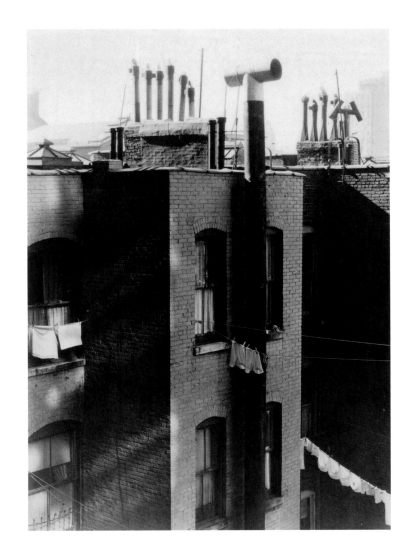

83

18. From the Window of Doctors Hospital, New York, Winter 1933

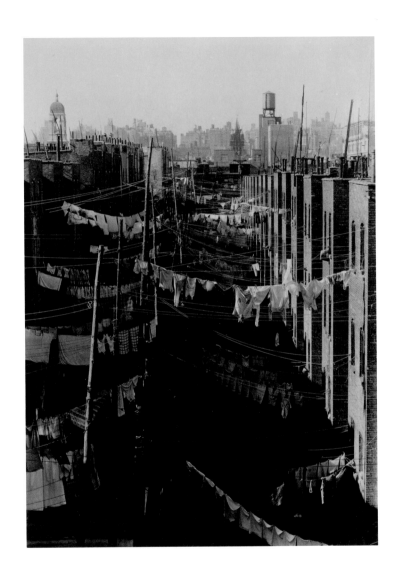

85

19. From the Window of Doctors Hospital, New York, Winter 1933

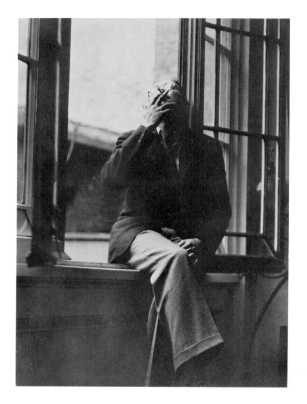

20. Jean Toomer, 39 West 10th Street, New York, Spring 1934

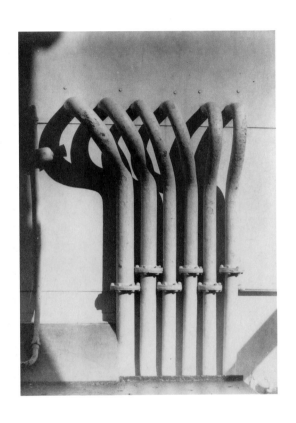

21. Steamship Pipes, Paris, Winter 1931

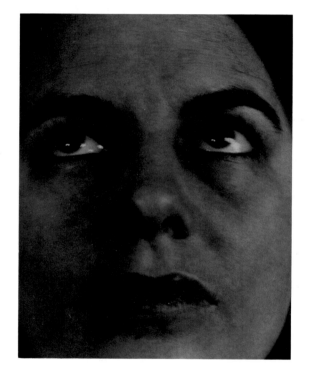

22. Helen Herendeen, c. 1926

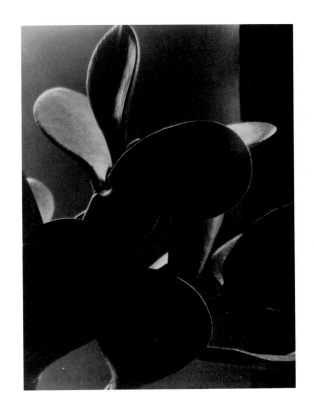

23. Jade Tree Leaves, c. 1928

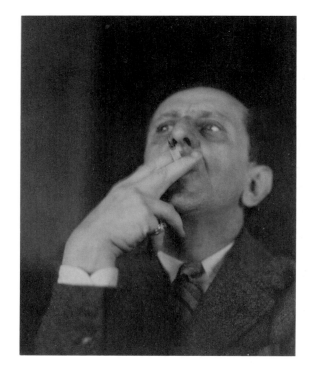

24. Marsden Hartley, c. 1929

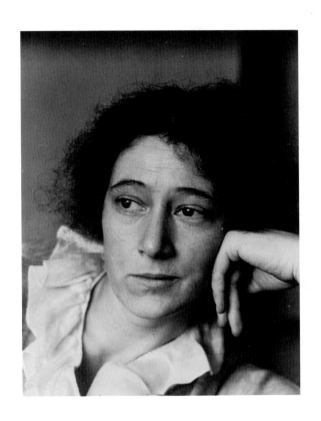

91

25. Consuelo Kanaga, c. 1928

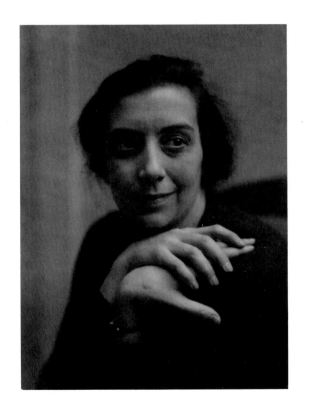

26. Self-portrait, c. 1928

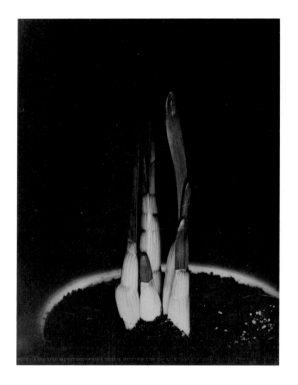

94

27. Bulbs, 1931

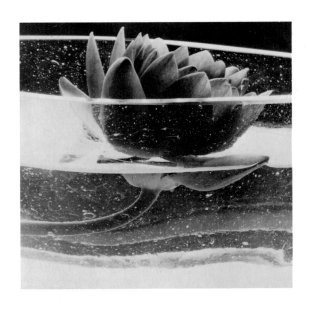

28. Water Lily, c. 1928

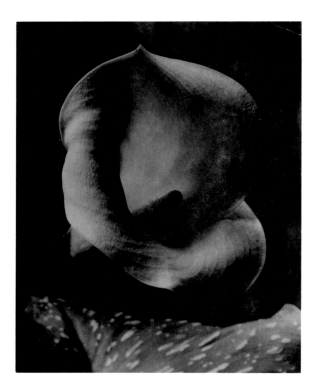

29. Calla Lily, 1931

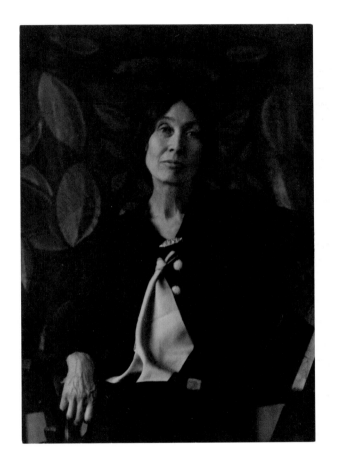

30. Lola Ridge, 1935

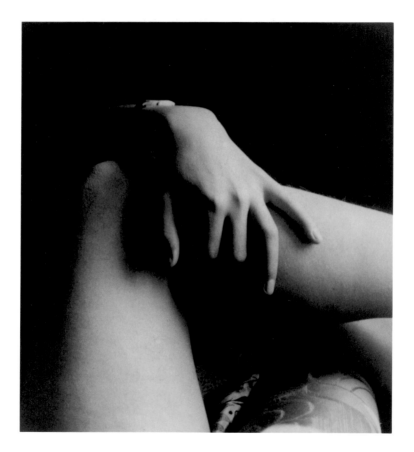

31. Susan Loeb, 1930

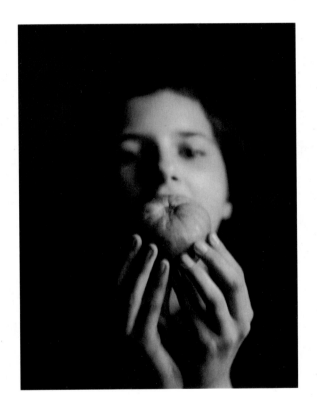

32. Susan Loeb, 1930

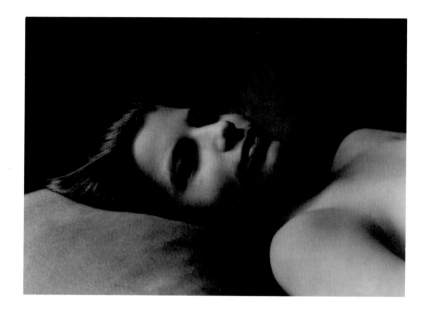

33. Susan Loeb, 1930

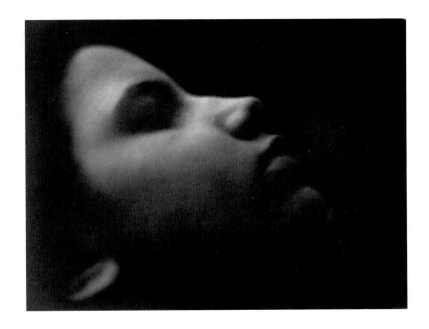

34. Susan Loeb, 1930

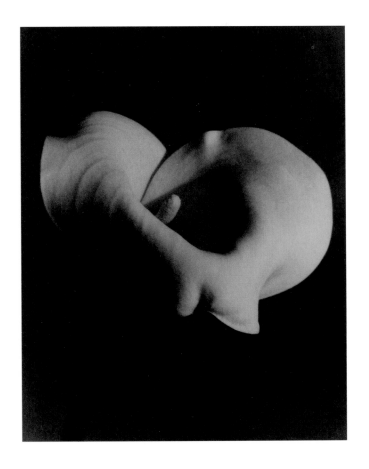

103

35. Calla Lily, 1931

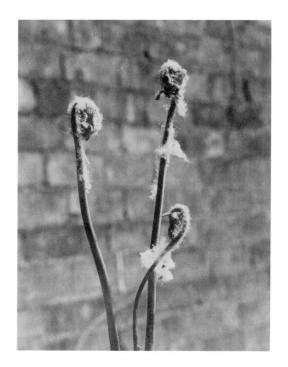

36. Ferns, c. 1934

37. Chaunce Dupee and Jean Toomer, Portage, Wisconsin, Summer 1934

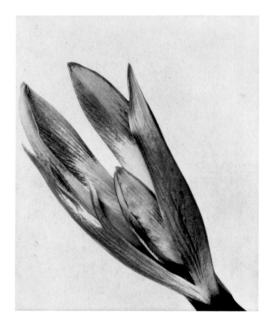

38. Budding Amaryllis, 1931

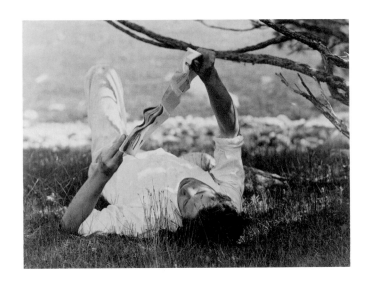

39. Edward Bright, c. 1930

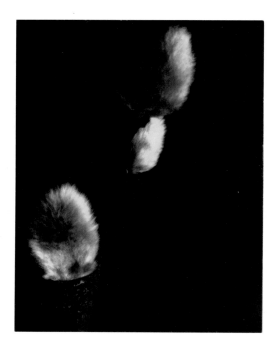

40. Pussywillows, c. 1928

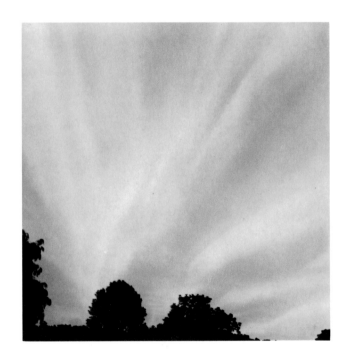

41. Skies at Mill House, Doylestown, Pennsylvania, 1941

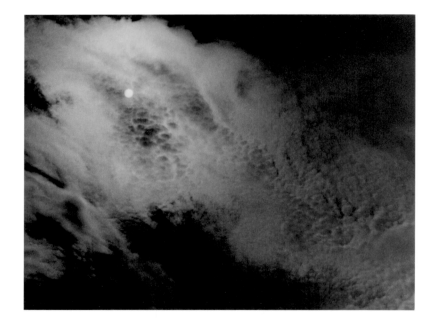

42. Moon with Clouds, Wading River, Long Island, c. 1928

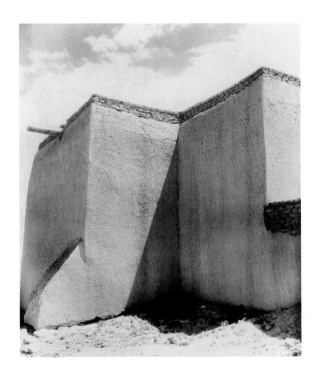

43. Las Trampas Church, New Mexico, Summer 1932

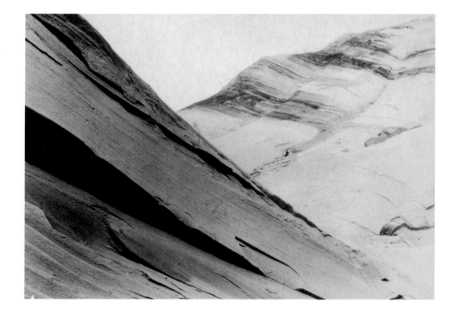

44. Rock Form, Summer 1932

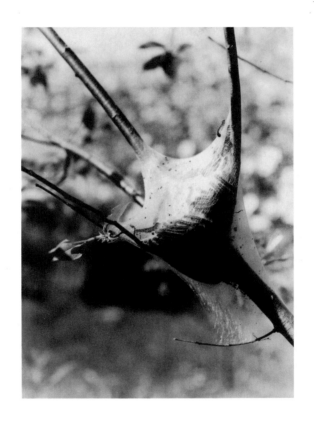

45. Tent Caterpillar, c. 1928

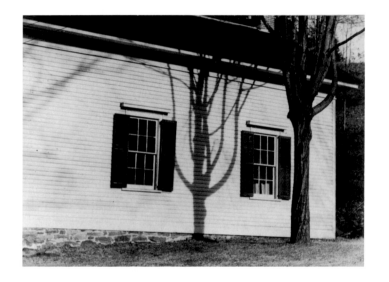

46. Church in Woodbury, Connecticut, January 2, 1933

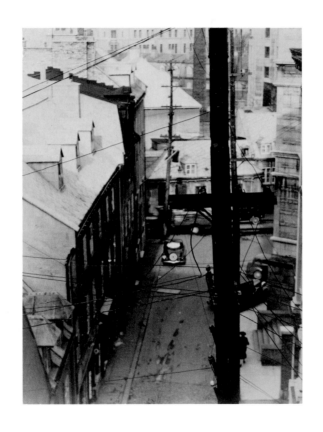

47. Quebec, October 1937

48. Quebec, October 1937

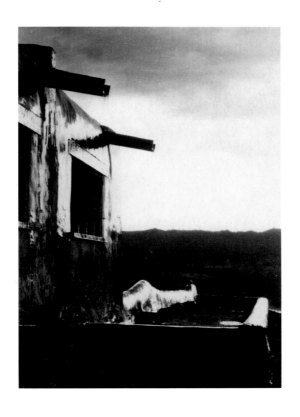

117

49. At Georgia O'Keeffe's Ghost Ranch, New Mexico, 1935

118

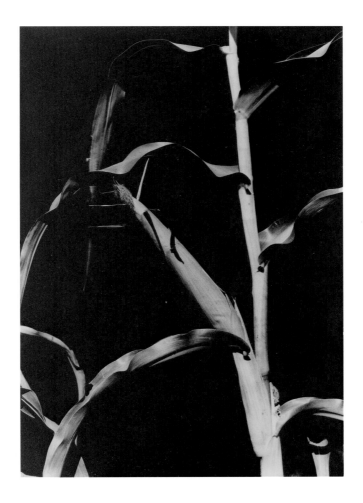

50. Cornstalk, Taos, Summer 1933

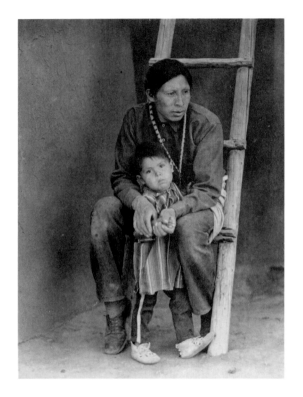

51. Adam Trujillo and His Son, Taos, Summer 1933

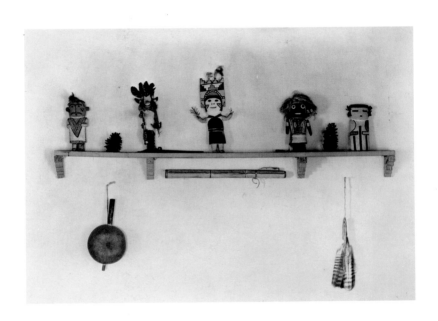

52. Kachinas at Juan Mirabel's, Taos, Summer 1933

53. Hill Behind Alice Evans House, Tesuque, New Mexico, Summer 1935

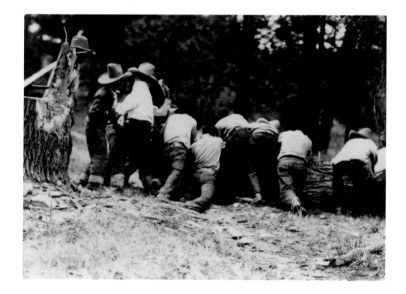

54. Big Springs, Whiteriver, Arizona, c. 1933

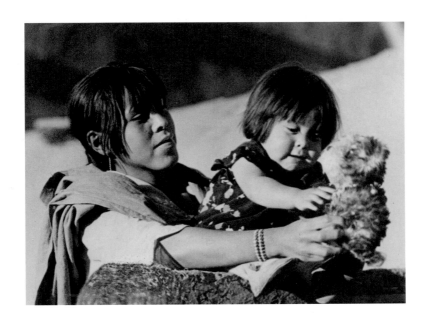

55. Maria Trujillo and Her Daughter, Taos, Summer 1933

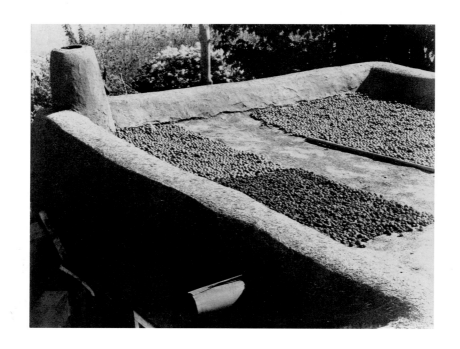

56. Wild Plums, Taos, Summer 1933

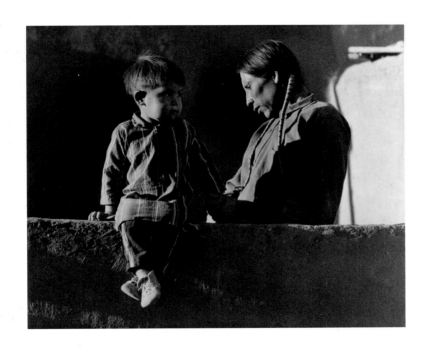

57. Adam Trujillo and His Son, Taos, Summer 1933

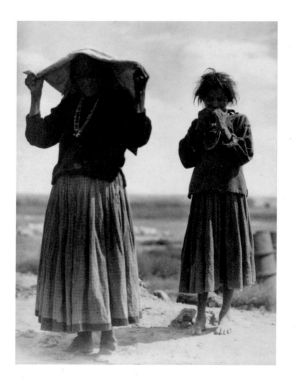

58. Navajo Women at Red Lake, Arizona, c. 1933

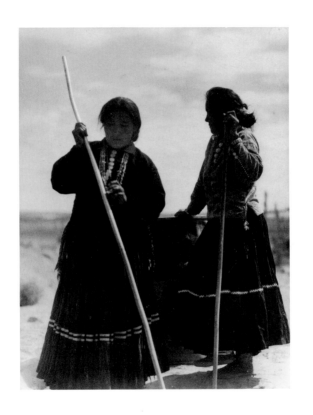

59. Navajo Women at Red Lake, Arizona, c. 1933

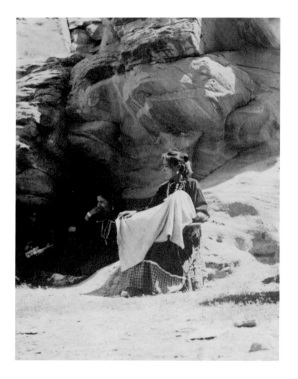

60. Navajo Women at Sheep Dip, Shonto, Arizona, c. 1933

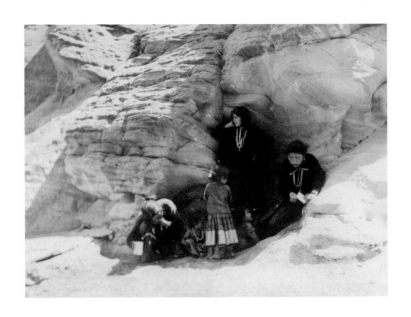

61. Navajo Women at Sheep Dip, Shonto, Arizona, c. 1933

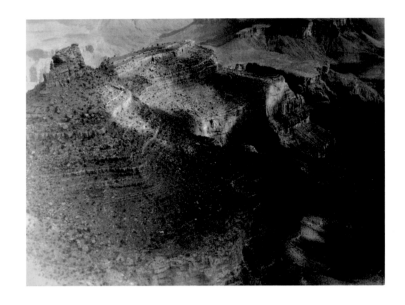

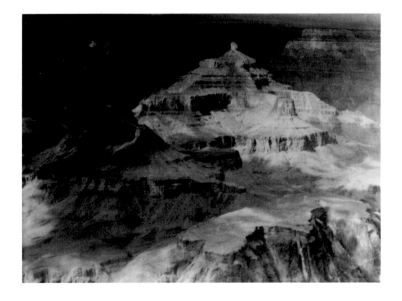

62 & 63. Grand Canyon, c. 1932

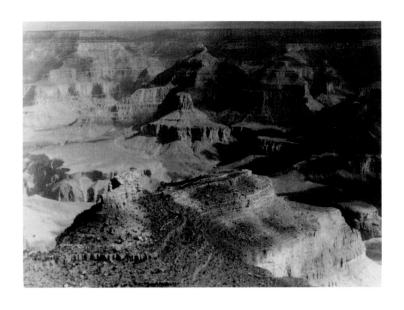

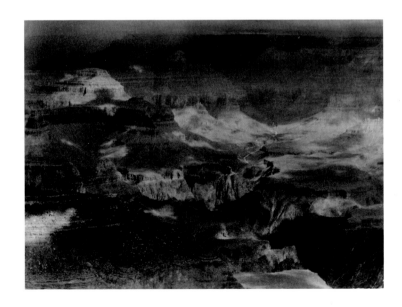

64 & 65. Grand Canyon, c. 1932

134

66. Genus Baird, Fort Defiance, Arizona, Summer 1932

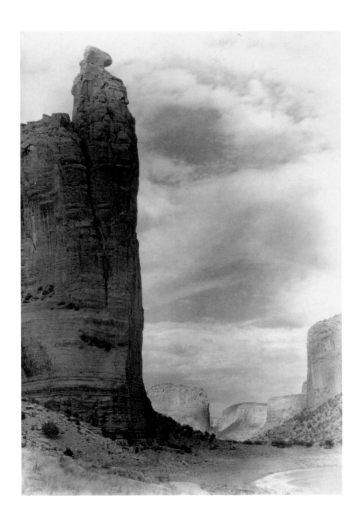

67. Canyon de Chelly, Summer 1932

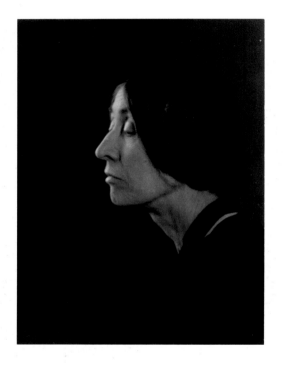

68. Lola Ridge, 1935

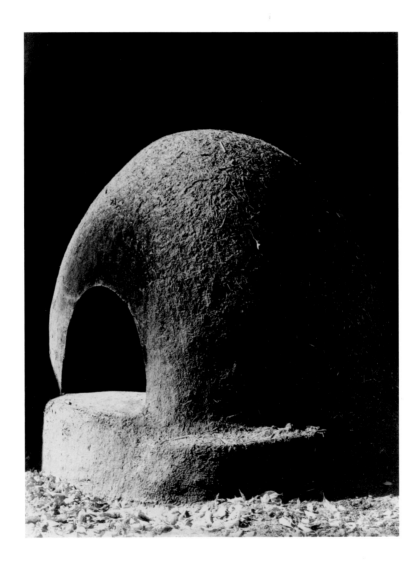

137

69. Juan Mirabel's Oven, Taos, Summer 1933

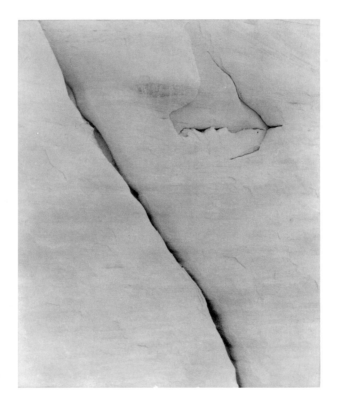

138

70. Blue Canyon Rock Form, Summer 1932

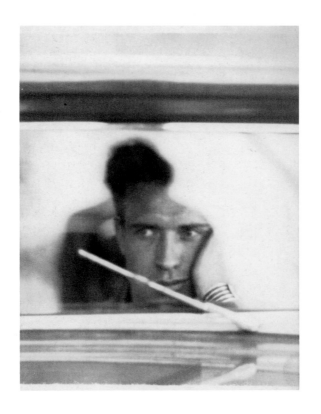

139

71. Gordon Grant, 1932

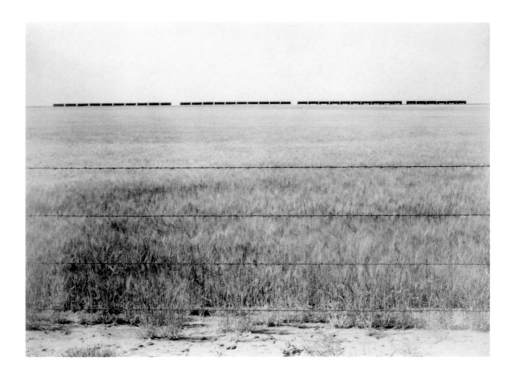

141

72. Kansas, Summer 1934

1895

February 17. Marjorie Alice Content born to Adrienne (Ada) Oberndorfer and Harry Content at 62 East 79th Street, New York. Marjorie is the Contents' second child and only daughter; her brother, Harold Augustus, is eight or nine years older.

1903

Moves to Saint Regis Hotel with her family.

1911

Moves to 11 East 45th Street with her father. (Ada Content was in and out of sanitariums throughout Marjorie's childhood and retired permanently to one during Marjorie's teens.)

1911–14

Attends Miss Finch's School. Meets Arthur and Mary Mowbray-Clarke, under whom she studies painting and English, respectively.

1912

Meets the painter William Zorach while visiting Alfred Stieglitz's gallery, 291, where she goes often with her classmate Dorothy Obermeyer and her friend Flora Stieglitz, Alfred's niece.

1914

April. Marries Harold A. Loeb (before graduating from Finch) at her father's apartment at 375 Park Avenue. Leaves that afternoon for Empress, in Alberta, Canada, with Harold; her French maid, Marthe; and two English setters.

September. After the outbreak of World War I, returns to New York with Harold.

1914–15

With Harold studies painting under William and Marguerite Zorach in Greenwich Village.

1915

Spring. Moves with Harold to a rented house in Hartsdale, New York.

June 26. Son Harold Albert (James) Loeb, Jr. (who will later legally change his name to James) delivered by Dr. Leopold Stieglitz, Alfred's brother, at Harry Content's apartment at 375 Park Avenue.

With Harold and Jim, lives for a short time in a basement apartment at 15 West 55th Street, where she has a miscarriage, and then in her

FIG. 29. *Marjorie Content*

uncle Walter Content's apartment at or near 59th Street and 7th Avenue.

1916

November 27. Daughter Mary Ellen (Susan) Loeb (who will later legally change her name to Susan, unaware that her brother had also legally changed his name many years earlier) delivered by Dr. Leopold Stieglitz at the Loebs' rented apartment at 68 East 86th Street.

1917

Spring. With the children, joins Harold in Palo Alto, California, where he manages his uncle Simon Guggenheim's copper firm for a brief time before returning to New York and enlisting in the U.S. Army.

1918

Returns to New York to be with Harold before he is sent to France, but when the armistice is signed and troop departures are canceled, goes back to Palo Alto to get the children and bring them to New York, where they all live in a one-and-a-half-room rented apartment in the East 50s.

1919

February. Becomes bookkeeper at The Sunwise Turn bookstore, then

at 2 East 31st Street (and later in the Yale Club building).

Alfred Stieglitz brings Georgia O'Keeffe to meet the Loebs at their apartment at 48 King Street.

Jim and Susan attend preschool at the Walden School.

1920

Helps Alfred Stieglitz open up his family home at Lake George, New York.

1921

With Harold, buys and then sells a partnership share in The Sunwise Turn.

Family moves to 3 East 9th Street, a house Harry Content has bought for his daughter. From his office in the basement, Harold launches *Broom,* a journal of literature and art.

Harold buys a "shack" in New City in Rockland County, New York.

Jim and Susan attend City and Country School.

Divorces Harold Loeb.

1922

Meets artist and set designer Michael Carr through her friend the actor Rollo Peters.

143

Fig. 30. *Susan Loeb* Fig. 31. *Jim Loeb*

Probably discusses photographic printing with friend Consuelo Kanaga (see plate 25), who has moved to New York to work as a photographer for the *New York American*.

New City shack burns down.

1923

With Michael Carr, designs and builds by hand a large fieldstone house behind the site of the shack in

New City. Has no darkroom in the house on East 9th Street, but is believed to have used Consuela Kanaga's.

1924

Marries Michael Carr.

1926

Probably this year, takes her first ambitious photographs: portraits of Bruce Christen and Helen Herendeen, friends and neighbors in New City, with a 3¼-x-4¼-inch Graflex, her first professional camera (see plates 15, 22).

1927

Michael dies from pneumonia.

Leaves New City, sells her house on East 9th Street, and rents an apartment at 29 Washington Square. Uses the bathroom as a darkroom.

1928

Photographs intensely.

Jim leaves City and Country School before his senior year and goes to boarding school in upstate New York, first at Mohonk School and then at Storm King School.

1929

March 15. Marries the poet Leon Fleischman. They live at 29 Washington Square.

1931

Susan graduates from City and Country School and attends Lenox School, the high school of Finch Junior College.

Summer. After recovering from a serious case of whooping cough, takes a cross-country camping trip with her children and twenty-one-year-old painter Gordon Grant (see plate 71). Visits Many Glacier in Canada (fig. 32), Glacier National Park in Montana, and Mesa Verde and friend Ralph Hubbard's ranch in Colorado.

Winter. Travels to Paris to try to save her marriage, but fails. Moves to 39 West 10th Street, a large brownstone her father has bought for her. Gordon Grant builds her a darkroom on the top floor. Photographs passionately.

FIG. 32. *Many Glacier, Canada, Summer 1931*

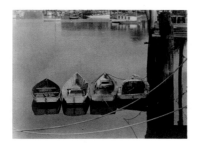

1932

Three of her photographs—
a walkway and trees in Washington
Square (a variant of plate 7), a street
scene viewed from Washington
Square (plate 1), and a cloud study
(plate 42)—are published in the
annual *Photographie* (Arts et Métiers
Graphiques, Paris, nos. 26, 27, 69).

Spring. Visits Alfred Stieglitz and
Georgia O'Keeffe at Lake George.

Uses a 5-x-7-inch Graflex cam-
era in addition to her 3¼-x-4¼.

Summer. Travels west again
with Gordon Grant. Takes Susan to
summer camp in Steamboat Springs,
Colorado. Visits Canyon de Chelly
(plate 67) and Canyon del Muerto in
Arizona; Enchanted Mesa, Gallup,
Albuquerque, and Ranchos de Taos
in Arizona; and Mesa Verde in
Colorado.

1933

Easter. Takes Georgia O'Keeffe
and Susan to Bermuda and nurses
O'Keeffe out of a debilitating
depression.

August. Begins photographing
Native American life for the Bureau
of Indian Affairs.

1934

Spring. Stint with the Bureau
of Indian Affairs ends. Returns to
the East. Through Fred Leighton,
who sells Native American artifacts
in New York, meets novelist Jean
Toomer.

Summer. Heads west again with
Georgia O'Keeffe. They stay at
Marie Garland's H & M Ranch in
Alcalde, New Mexico, where Jean
joins them.

August 31. Divorce
from Leon Fleischman
becomes final.

September 1.
Marries Jean Toomer
in Taos, New Mexico.
Susan and Jim and
friends Georgia
O'Keeffe, Franklin

(Lin) Davenport (see fig. 39), and
Willard (Spud) Johnson attend.

Returns east with Jean, stopping
at Max and Shirley Grove's in Illinois
to pick up Jean's two-year-old
daughter Margery (Margot), whose
mother died in childbirth, and in
Portage, Wisconsin, to visit Margot's
maternal grandmother, Mrs. C. W.
("Mother") Latimer.

145

FIG. 33. *Darien, Connecticut, c. 1933*

FIG. 34. *At Alfred Stieglitz's, Lake George, New York, Spring 1932*

1935

Four of her photographs—of a rock form (plate 44), haystacks, an alleyway with lines of laundry (plate 19), and a snowy backyard (plate 6) —are published in *Photographie* (nos. 48, 49, 108, 109).

Summer. Travels to New Mexico with Jean. She photographs, he writes.

November 21. Moves with Jean to Mill House, a farm in Doylestown, Bucks County, Pennsylvania, that Harry Content has bought. On the property are Mill House itself, a butcher house, a mill, and a barn.

Goes back to photographing with a 3¼-x-4¼-inch Graflex.

1936

Spring. Begins restoring the old mill.

Susan leaves for college in Chicago; mother and daughter begin corresponding.

Moves permanently with Jean to Doylestown, although still owns 39 West 10th Street.

1937

Summer. Mother Latimer and Charles (Chaunce) Dupee (see plate 37) visit.

Fall. Young Paul Taylor, son of friend Edith Taylor, lives with the Toomers and attends Buckingham Friends School with Margot.

October. Takes a twelve-day trip to Marblehead, Massachusetts, and Quebec with Jean (see plates 47, 48; fig. 18), traveling through Lake George and Plattsburgh, New York, and Montreal.

1938

Has second miscarriage. (The first was in 1915.)

Becomes involved with the Buckingham Friends School and the Religious Society of Friends.

Begins having most of her photographs commercially developed.

1939

August. Sails to India with Jean and Margot.

146

FIG. 35. *Cleaning up the farm, Doylestown, Pennsylvania, 1936*

FIGS. 36 & 38. *Rice's sale, Solebury, Bucks County, Pennsylvania, c. 1941*

1940
February. Jean loses a kidney.
Becomes a member of the
Buckingham Meeting of the
Religious Society of Friends.

1941
Converts the old butcher house
on the farm into a darkroom but
photographs only sporadically.

Uses a 2¼-x-2¼-inch Rolleiflex
as well as her 3¼-x-4¼-inch Graflex.

August. Harry Content dies
while Marjorie and Jean are in Salt
Lake City, Utah, on their way to visit
Susan in Oakland, California.

1942
Sells 39 West 10th Street.

1945
Sells the farm across the road
from Mill House that was part of the
original property.

1947
Summer. Returns to the West.
Visits Ranchos de Taos, Elephant
Butte, Santa Fe, Pecos Pueblo,
Las Vegas, and Raton, New Mexico,
as well as Kansas City.

Helps revive Doylestown
Monthly Meeting of the Religious
Society of Friends and transfers
membership to it. (The Meeting has
been active ever since.)

1953
Summer. Returns to the West
without Jean. After a week's stay
with Consuelo Kanaga and her hus-
band, Wallace Putnam, at Hawk
Ranch near Santa Fe, visits Ranchos
de Taos with Georgia O'Keeffe and
Georgia's sister Claudia.

Takes photographs, but now
only as family records.

1955
Sells Mill House, Butcher
House, and the mill and renovates
and moves into the barn on the
property.

1960
Places Jean in a nursing home.

147

FIG. 37. *Mill House, Butcher House (later Content's darkroom),
and the mill, Doylestown, Pennsylvania, January 1936*

1962

December. Arranges to send the Toomer papers, on loan, to Fisk University in Nashville. (In 1985, after years of litigation, the papers go to the Beinecke Library at Yale University.)

1967

March 30. Jean Toomer dies.

1970

March 18. Jim Loeb dies.

1980

Susan (now Susan Sandberg) moves into separate quarters in the old barn.

1982

Susan's son, Keith, and his wife, Nancy, move into the old barn.

1984

August 20. Dies at Doylestown Hospital with her grandson, Keith, and his wife, Nancy, at her side.

FIG. 39. *Jean Toomer and Lin Davenport pitching wheat, Doylestown, Pennsylvania, July 1937*

Marjorie Content's earliest extant ambitious photographs are likely to be either her still lifes (plates 11–13, 16, 17), which she dated circa 1928 or her portraits of Bruce Christen and Helen Herendeen (plates 15, 22), which she dated circa 1926 and 1926, respectively. All were taken with a 3¼-x-4¼-inch Graflex, Content's first professional camera. The folder containing the still-life negatives was titled "Still Life—very early (learning)." The negatives of the portraits of Christen and Herendeen, Content's friends and neighbors in New City, New York, where she and Michael Carr lived in part from 1923 to 1927, were found in a box of 3¼-x-4¼-inch negatives labeled "early negatives."

Dating other photographs is, however, often problematical. There is good reason to believe that Content added dates to the backs or the mounts of some of her photographs as late as the early 1980s and that she was sometimes in error.

Although Content dated one of her portraits of her friend Lola Ridge (fig. 24) 1925 on the mount and wrote *c. 1925* on the verso of another (plate 68), those pictures and plate 30 were probably taken in 1935, along with a group of other portraits

that show Ridge at more or less the same age and the negatives for which are all dated 1935.

Content dated her study of Henry Varnum Poor's hands and palette (fig. 9) circa 1926. Since she and Poor were friends from New City, she must have, at the time she dated the picture, associated it with that period of her life. It was printed, however, from a 5-x-7-inch negative that is dated winter 1933. Content did not begin using the larger Graflex until spring 1932.

One of the prints of Content's photographs of her daughter, Susan Loeb Sandberg (plate 31), and some of her flower studies (plates 4, 14, 27, 35, 38) are dated 1928 or circa 1928. The negatives of all of Content's pictures of her daughter are stored in a sleeve labeled "Sue at Washington Square—1930," and those of the flower studies (along with negatives for many similar studies, including plate 9 and variants of plates 10 and 29) are in a sleeve dated 1931. We have therefore redated the prints.

Content dated a photograph of the backyard of her house at 39 West 10th Street (plate 6) 1930, the year before she moved there. She visited Wading River, Long Island (see plate 42), in 1928, not 1933, the date she

149

wrote on the picture she took there (which, in fact, was published in the French journal *Photographie* in 1932). *Cornstalk* (plate 50), dated circa 1932 on the verso, was probably taken in 1933; its negative was found in an album titled "Bermuda, 1933, Summer, 1933." The view of a building and chimney pipes that Content dated 1926 (plate 18) proves to be a view from an upper-story window of Doctors Hospital in New York, where she visited her friend Billy Whiting, who was a patient there during the winter of 1933 (see also plate 19).

Two of the three pictures of Quebec included here (plate 48 and fig. 18) were dated circa 1932 by Content, but they and plate 47 were actually taken during a trip she took with Jean Toomer in October 1937.

Between the spring of 1932 and the spring of 1934 Content used a 5-x-7-inch Graflex camera in addition to her 3¼-x-4¼. Eight rolls of 35mm negatives from the early 1930s indicate that she also used a Leica at that time, and from two glass negatives showing images of the backyard at 39 West 10th Street we also know that in the early 1930s she used both celluloid and glass negatives with her 5-x-7-inch Graflex. From 1935 to 1941 she worked with the smaller

Graflex, and from 1941 to 1948 she used both the smaller Graflex and the 2¼-x-2¼-inch twin-lens reflex Rolleiflex. She used the Rolleiflex from 1941 until the end of her life, but she used it mostly for snapshots, just the way she had used her Brownie camera from childhood until the beginning of her ambitious work.

1. FROM WASHINGTON SQUARE, NEW YORK, C. 1928
Signed, titled *From Washington Square,* and dated by the artist in pencil, with the artist's printing notations and MC-56-C in pencil, verso
3¹³⁄₁₆ x 2⅞ in. (9.6 x 7.5 cm)
Published: Photographie 1932, *no. 27*
Metropolitan Museum of Art, New York

2. PARIS—RAIN, WINTER 1931
Titled *Paris—rain* by the artist in pencil, with the artist's printing notations in pencil, verso; numbered 5 in Susan L. Sandberg's hand in pencil, verso
3⅞ x 2¹⁵⁄₁₆ in. (9.8 x 7.5 cm)
Metropolitan Museum of Art, New York

3. WASHINGTON SQUARE, NEW YORK, C. 1928
Signed and dated by the artist in pencil, with MC-57-C in pencil, verso
2¹⁵⁄₁₆ x 4 in. (7.5 x 10.2 cm)
Collection of Jill Quasha, New York

4. AMARYLLIS, 1931
Signed and dated *c. 1928* by
the artist in pencil, with the artist's
printing notations and MC-32-C in
pencil, verso
2¹¹⁄₁₆ x 3⁷⁄₁₆ in. (6.8 x 8.7 cm)
Chrysler Museum, Norfolk, Virginia

5. WASHINGTON SQUARE,
NEW YORK, C. 1928
Signed and dated by the artist in
pencil, with the artist's printing nota-
tions and MC-53-C in pencil, verso
3 x 3¹⁵⁄₁₆ in. (7.6 x 10 cm)

6. BACKYARD, 39 WEST 10TH
STREET, NEW YORK, 1931
Mounted by the artist; signed
and dated *1930* by the artist in
pencil, lower right of mount; titled
Backyard, 39 W. 10th and numbered
1 in Susan L. Sandberg's hand in
pencil, verso
Image: 6⅜ x 4⅜ in.
(16.2 x 11.1 cm)
Mount: 14¹⁵⁄₁₆ x 11¹⁵⁄₁₆ in.
(37.9 x 30.3 cm)
Published: Photographie 1935, no. 109
Private collection, Washington, D.C.

7. WASHINGTON SQUARE,
NEW YORK, C. 1928
Signed and dated *1928* in pencil
and numbered *58* in green ink by the
artist, verso; titled *Washington Square*

and numbered *3* in Susan L. Sand-
berg's hand in pencil, verso
4⁹⁄₁₆ x 6⅛ in. (11.6 x 15.6 cm)
Chrysler Museum, Norfolk, Virginia

8. MARY HAMLIN'S COURTYARD,
TAOS, SUMMER 1933
Signed and dated by the artist in
pencil, with the artist's printing nota-
tions and MC-106-C in pencil, verso
4⁹⁄₁₆ x 6⁷⁄₁₆ in. (11.6 x 16.3 cm)
Private collection, North Conway,
New Hampshire

9. AMARYLLIS, 1931
Signed in pencil and numbered
32 in green ink by the artist, verso;
numbered *41* in Susan L. Sandberg's
hand in pencil, verso
2⅞ x 3⅞ in. (7.3 x 9.8 cm)

10. ANTHURIUM IN VASE, 1931
Signed and dated *c. 1928*
by the artist in pencil, with MC-4 in
pencil, verso
6⁷⁄₁₆ x 4¼ in. (16.3 x 10.8 cm)
Collection of Robin and Sandy Stuart,
Houston

11. PIANO STRINGS, C. 1928
Signed and dated by the artist in
pencil, with the artist's printing nota-
tions and MC-19-C in pencil, verso
2¹⁵⁄₁₆ x 3¹³⁄₁₆ in. (7.5 x 9.6 cm)
Collection of Anne Kennedy Nadin, New York

12. CHESS PIECES, C. 1928
Signed and dated by the artist in
pencil, with MC-18-C in pencil, verso
2⁹⁄₁₆ x 4 in. (6.5 x 10.2 cm)
Collection of Marjorie and Leonard Vernon,
Los Angeles

13. CIGARETTE PACK WITH
MATCHES, C. 1928
Signed and dated by the artist in
pencil, with the artist's printing nota-
tions in pencil, verso
3⅝ x 2⅞ in. (9.2 x 7.3 cm)

14. CALLA LILY AND LEAF, 1931
Mounted by the artist; signed
M Content in pencil, lower right
of mount; signed, dated *c. 1928,* and
annotated *29 Wash Squ.* by the artist
in pencil, verso
Image: 6⁵⁄₁₆ x 4¾ in.
(16 x 12.1 cm)
Mount: 11¹³⁄₁₆ x 9⁷⁄₁₆ in.
(30 x 24 cm)
Museum of Fine Arts, Houston

15. BRUCE CHRISTEN, C. 1926
Artist's printing notations in
pencil, verso
3⅞ x 2¹⁵⁄₁₆ in. (9.8 x 7.5 cm)
Chrysler Museum, Norfolk, Virginia

16. CIGARETTES ON TRAY, C. 1928
Signed and dated by the artist
in pencil, with the artist's printing

notations and MC-2 in pencil, verso
3¹³⁄₁₆ x 3 in. (9.7 x 7.6 cm)
Collection of Howard Greenberg, New York

17. VAT 69, C. 1928
Signed and dated by the artist in
pencil, with MC-1 in pencil, verso
2⅞ x 3½ in. (7.3 x 8.9 cm)
Collection of Marjorie and Leonard Vernon,
Los Angeles

18. FROM THE WINDOW OF
DOCTORS HOSPITAL, NEW YORK,
WINTER 1933
Signed and dated *1926* by
the artist in pencil, with the artist's
printing notations and MC-61-C in
pencil, verso
6⅜ x 4⁹⁄₁₆ in. (16.2 x 11.6 cm)
University Art Museum, University of
New Mexico, Albuquerque

19. FROM THE WINDOW OF
DOCTORS HOSPITAL, NEW YORK,
WINTER 1933
Signed and dated *c. 1933* by the
artist in pencil, with MC-66-C and *Best*
print of this in pencil, verso
6¹¹⁄₁₆ x 4⁹⁄₁₆ in. (17 x 11.6 cm)
Published: Photographie 1935, *no. 108*
Collection of Joseph E. Seagram and Sons,
Inc., New York

20. JEAN TOOMER, 39 WEST 10TH
STREET, NEW YORK, SPRING 1934

Signed by the artist in pencil,
with the artist's printing notations in
pencil, verso

> 3⅞ x 2⅞ in. (9.8 x 7.3 cm)
>
> *Collection of Anne Kennedy Nadin, New York*

21. STEAMSHIP PIPES, PARIS,
WINTER 1931

Titled *Paris* and numbered
226 in Susan L. Sandberg's hand in
pencil, verso

> 3¹³⁄₁₆ x 2¹¹⁄₁₆ in. (9.7 x 6.8 cm)

22. HELEN HERENDEEN, C. 1926

Signed by the artist in pencil,
with the artist's printing notations in
pencil, verso

> 3⅝ x 2⅞ in. (9.2 x 7.3 cm)
>
> *Collection of Anne Kennedy Nadin, New York*

23. JADE TREE LEAVES, C. 1928

Signed and dated by the artist in
pencil, with the artist's printing nota-
tions and *MC-34-C* in pencil, verso

> 3¹³⁄₁₆ x 2¹³⁄₁₆ in. (9.7 x 7.1 cm)
>
> *Private collection, North Conway,*
> *New Hampshire*

24. MARSDEN HARTLEY, C. 1929

Signed and dated by the artist in
pencil, with the artist's printing nota-
tions and *MC-48-C* in pencil, verso

> 3⅝ x 2⅞ in. (9.2 x 7.3 cm)
>
> *Collection of Ealan Wingate, New York*

25. CONSUELO KANAGA, C. 1928

Signed and dated by the artist in
pencil, with *MC-43-C* in pencil, verso

> 3¹³⁄₁₆ x 2¹⁵⁄₁₆ in. (9.7 x 7.5 cm)

26. SELF-PORTRAIT, C. 1928

Signed by the artist in pencil,
with the artist's printing notations in
pencil, verso; numbered *100* in Susan
L. Sandberg's hand in pencil, verso

> 3¹³⁄₁₆ x 2¹³⁄₁₆ in. (9.7 x 7.1 cm)

27. BULBS, 1931

Signed and dated *c. 1928* by the
artist in pencil, with the artist's printing
notations and *MC-33-C* in pencil, verso

> 3¹³⁄₁₆ x 2⅞ in. (9.7 x 7.3 cm)
>
> *Collection of Tina Davis and James Snyder,*
> *New York*

28. WATER LILY, C. 1928

Signed and dated by the artist in
pencil, with the artist's printing nota-
tions and *MC-3* in pencil, verso

> 2¹³⁄₁₆ x 2⅞ in. (7.1 x 7.3 cm)
>
> *Collection of Rolf Mayer, Stuttgart*

29. CALLA LILY, 1931

Signed in pencil and numbered
22 in green ink by the artist, with
the artist's printing notations in pen-
cil, verso; numbered *42* in Susan L.
Sandberg's hand in pencil, verso

> 5⅝ x 4⁹⁄₁₆ in. (14.3 x 11.6 cm)

153

30. LOLA RIDGE, 1935

Signed in pencil and numbered *42* in green ink by the artist, verso; numbered *87* in Susan L. Sandberg's hand in pencil, verso

6⅝ x 4⅝ in. (16.8 x 11.7 cm)

31. SUSAN LOEB, 1930

Signed and dated *c. 1928* in pencil and numbered *8* in green ink by the artist, verso; numbered *90* in Susan L. Sandberg's hand in pencil, verso

5⁹⁄₁₆ x 5¹⁄₁₆ in. (14.2 x 12.8 cm)

Private collection, North America

32. SUSAN LOEB, 1930

Signed in pencil and numbered *9* in green ink by the artist, with the artist's printing notations in pencil, verso; numbered *94* in Susan L. Sandberg's hand in pencil, verso

3¾ x 2¹³⁄₁₆ in. (9.5 x 7.1 cm)

33. SUSAN LOEB, 1930

Signed in pencil and numbered *37* in green ink by the artist, with the artist's printing notations in pencil, verso; numbered *109* in Susan L. Sandberg's hand in pencil, verso

2¹⁵⁄₁₆ x 4 in. (7.5 x 10.2 cm)

34. SUSAN LOEB, 1930

Signed in pencil and numbered *38* in green ink by the artist, with the artist's printing notations in pencil,

verso; numbered *115* in Susan L. Sandberg's hand in pencil, verso

3¹⁄₁₆ x 3¹⁵⁄₁₆ in. (7.7 x 10 cm)

35. CALLA LILY, 1931

Mounted by the artist; signed and dated *1928* by the artist in pencil, lower right of mount; numbered *7* by the artist in green ink, verso of mount; numbered *45* in Susan L. Sandberg's hand in pencil, verso of mount

Image: 6⅛ x 4⁹⁄₁₆ in. (15.6 x 11.6 cm)

Mount: 11¹³⁄₁₆ x 9⁵⁄₁₆ in. (30 x 23.6 cm)

36. FERNS, C. 1934

Signed and titled *Ferns* in pencil and numbered *33* in green ink by the artist, verso; numbered *40* in Susan L. Sandberg's hand in pencil, verso

3½ x 2¹¹⁄₁₆ in. (8.9 x 6.8 cm)

37. CHAUNCE DUPEE AND JEAN TOOMER, PORTAGE, WISCONSIN, SUMMER 1934

Annotated *1 for Chaunce* in pencil by the artist, with the artist's printing notations in pencil, verso; numbered *113* in Susan L. Sandberg's hand in pencil, verso

3⁹⁄₁₆ x 2¹¹⁄₁₆ in. (9 x 6.8 cm)

Collection of Eugenia Parry Janis, Santa Fe

38. BUDDING AMARYLLIS, 1931
Signed and dated *c. 1928* by the
artist in pencil, with the artist's printing
notations and *MC-31-C* in pencil, verso
3¹¹⁄₁₆ x 2¹⁵⁄₁₆ in. (9.3 x 7.5 cm)

39. EDWARD BRIGHT, C. 1930
Artist's printing notations and
Edward Bright in pencil, verso; num-
bered *202* in Susan L. Sandberg's
hand in ink, verso
2⁷⁄₈ x 3¹¹⁄₁₆ in. (7.3 x 9.4 cm)

40. PUSSYWILLOWS, C. 1928
Signed and titled *pussies* by the
artist in pencil, with the artist's
printing notations in pencil, verso;
numbered *36* in Susan L. Sandberg's
hand in pencil, verso
3¹³⁄₁₆ x 3 in. (9.6 x 7.6 cm)

41. SKIES AT MILL HOUSE,
DOYLESTOWN, PENNSYLVANIA, 1941
Signed in pencil, with the
artist's printing notations in pencil,
verso; numbered *74* by the artist in
green ink, verso of mat; numbered *7*
in Susan L. Sandberg's hand in pen-
cil, verso of mat
4½ x 4¹¹⁄₁₆ in. (11.4 x 11.9 cm)

42. MOON WITH CLOUDS, WAD-
ING RIVER, LONG ISLAND, C. 1928
Signed and dated *c. 1933* by the
artist in pencil, with the artist's printing
notations and *MC-11-C* in pencil, verso

4¾ x 6⁵⁄₁₆ in. (12.1 x 16 cm)
Published: Photographie 1932, *no. 69*
Hallmark Photographic Collection, Hallmark
Cards, Inc., Kansas City, Missouri

43. LAS TRAMPAS CHURCH,
NEW MEXICO, SUMMER 1932
Signed and dated *1932–4* in
pencil and numbered *100* in green
ink by the artist, with the artist's
printing notations in pencil, verso;
numbered *137* in Susan L. Sandberg's
hand in pencil, verso
5⁷⁄₁₆ x 4⁹⁄₁₆ in. (13.8 x 11.6 cm)
Private collection, Washington, D.C.

44. ROCK FORM, SUMMER 1932
Signed in pencil, with the
artist's printing notations in pencil,
verso; numbered *21* in Susan L.
Sandberg's hand in pencil, verso
4⁹⁄₁₆ x 6⁷⁄₁₆ in. (11.6 x 16.3 cm)
Published: Photographie 1935, *no. 48*

45. TENT CATERPILLAR, C. 1928
Artist's printing notations in
pencil, verso; numbered *254* in Susan
L. Sandberg's hand in pencil, verso
6 x 4⁷⁄₁₆ in. (15.2 x 11.2 cm)

46. CHURCH IN WOODBURY,
CONNECTICUT, JANUARY 2, 1933
Signed in pencil, with the artist's
printing notations in pencil, verso
2¹³⁄₁₆ x 3¾ in. (7.1 x 9.5 cm)

155

47. QUEBEC, OCTOBER 1937
Signed in pencil and numbered
13 in green ink by the artist, verso;
numbered *4* in Susan L. Sandberg's
hand in pencil, verso
3¹⁵⁄₁₆ x 2¹⁵⁄₁₆ in. (10 x 7.5 cm)

48. QUEBEC, OCTOBER 1937
Signed and dated *c. 1932* by the
artist in pencil, with the artist's printing
notations and MC-69-C in pencil, verso
4 x 2¹⁵⁄₁₆ in. (10.2 x 7.5 cm)
Private collection, Washington, D.C.

49. AT GEORGIA O'KEEFFE'S
GHOST RANCH, NEW MEXICO, 1935
Signed in pencil, with the artist's
printing notations in pencil, verso
4 x 2¹⁵⁄₁₆ in. (10.2 x 7.5 cm)

50. CORNSTALK, TAOS,
SUMMER 1933
Signed, titled *Taos,* and dated
c. 1932 by the artist in pencil, with the
artist's printing notations and MC-77-C
in pencil, verso
6⅜ x 4⁹⁄₁₆ in. (16.2 x 11.6 cm)
Private collection, Amarillo, Texas

51. ADAM TRUJILLO AND HIS
SON, TAOS, SUMMER 1933
Artist's printing notations in
pencil, verso; numbered *210* in Susan
L. Sandberg's hand in ink, verso
3¾ x 2¹³⁄₁₆ in. (9.5 x 7.1 cm)

52. KACHINAS AT JUAN
MIRABEL'S, TAOS, SUMMER 1933
Titled *Katchinas at Juan Mirabel's,
Taos* by the artist in pencil, with the
artist's printing notations in pencil,
verso; numbered *14* in Susan L.
Sandberg's hand in pencil, verso
4½ x 6⁵⁄₁₆ in. (11.4 x 16.1 cm)
*Collection of Heidi and David Fitz,
Cumberland, Maine*

53. HILL BEHIND ALICE EVANS
HOUSE, TESUQUE, NEW MEXICO,
SUMMER 1935
Mounted by the artist; titled
Hill Behind Alice Evans House, Tesuque
and dated by the artist in pencil,
verso of mount
Image: 3⅜ x 4⁹⁄₁₆ in.
(8.6 x 11.6 cm)
Mount: 12½ x 10³⁄₁₆ in.
(31.8 x 25.9 cm)
Private collection, New York

54. BIG SPRINGS, WHITERIVER,
ARIZONA, C. 1933
Signed and dated *1932–34* by the
artist in pencil, with the artist's printing
notations and MC-88-C in pencil, verso
2¹³⁄₁₆ x 3¹³⁄₁₆ in. (7.1 x 9.7 cm)
Collection of Anne Kennedy Nadin, New York

55. MARIA TRUJILLO AND
HER DAUGHTER, TAOS, SUMMER 1933
Mounted by the artist;

numbered *118* in Susan L. Sandberg's
hand in pencil, verso
> Image: 4⅜ x 5⅞ in.
> (11.1 x 14.9 cm)
> Mount: 15¾ x 12⅜ in.
> (40 x 31.4 cm)
> *Collection of Annie and Vince Carrino,*
> *Portola Valley, California*

56. WILD PLUMS, TAOS,
SUMMER 1933
> Dry mounted by the artist;
numbered *161* in Susan L. Sandberg's
hand in pencil, verso
> 4⅝ x 6 in. (11.7 x 15.2 cm)

57. ADAM TRUJILLO AND HIS
SON, TAOS, SUMMER 1933
> Mounted by the artist
> Image: 4⁹⁄₁₆ x 5⅝ in.
> (11.6 x 14.3 cm)
> Mount: 15¹⁵⁄₁₆ x 12⁷⁄₁₆ in.
> (40.5 x 31.6 cm)
> *Collection of Charley and Rogie Dickey,*
> *Devon, Pennsylvania*

58. NAVAJO WOMEN AT RED
LAKE, ARIZONA, C. 1933
> Artist's printing notations in
pencil, verso; numbered *211* in Susan
L. Sandberg's hand in ink, verso
> 3⅝ x 2¾ in. (9.2 x 7 cm)

59. NAVAJO WOMEN AT RED
LAKE, ARIZONA, C. 1933
> Artist's printing notations in

pencil, verso; numbered *52* in Susan
L. Sandberg's hand in pencil, verso
> 3¹³⁄₁₆ x 2¹³⁄₁₆ in. (9.6 x 7.1 cm)

60. NAVAJO WOMEN AT SHEEP
DIP, SHONTO, ARIZONA, C. 1933
> Mounted by the artist; signed and
dated *1933* by the artist in pencil,
lower right of mount; numbered *96*
by the artist in green ink, verso of
mount; numbered *49* in Susan L. Sandberg's hand in pencil, verso of mount
> Image: 3⅝ x 2¾ in.
> (9.2 x 7 cm)
> Mount: 5⁵⁄₁₆ x 4⅜ in.
> (15.1 x 11 cm)

61. NAVAJO WOMEN AT SHEEP
DIP, SHONTO, ARIZONA, C. 1933
> Artist's printing notations in
pencil, verso; numbered *51* in Susan
L. Sandberg's hand in pencil, verso
> 2⅞ x 3¹³⁄₁₆ in. (7.3 x 9.6 cm)

62. GRAND CANYON, C. 1932
> Artist's printing notations in
pencil, verso; numbered *25* in Susan
L. Sandberg's hand in pencil, verso
> 2¹⁵⁄₁₆ x 3¹⁵⁄₁₆ in. (7.5 x 10 cm)

63. GRAND CANYON, C. 1932
> Artist's printing notations in
pencil, verso; numbered *24* in Susan
L. Sandberg's hand in pencil, verso
> 2¹⁵⁄₁₆ x 3⅞ in. (7.5 x 9.8 cm)

157

64. GRAND CANYON, C. 1932
Numbered *27* in Susan L.
Sandberg's hand in pencil, verso
2¹⁵⁄₁₆ x 3⅞ in. (7.5 x 9.8 cm)

65. GRAND CANYON, C. 1932
Artist's printing notations in
pencil, verso; numbered *23* in Susan
L. Sandberg's hand in pencil, verso
2¹⁵⁄₁₆ x 3¹⁵⁄₁₆ in. (7.5 x 10 cm)

66. GENUS BAIRD, FORT
DEFIANCE, ARIZONA, SUMMER 1932
Titled *Genus Baird, Fort Defiance*
by the artist in pencil, with the
artist's printing notations in pencil,
verso; numbered *246* in Susan L.
Sandberg's hand in pencil, verso
3⅝ x 2¹³⁄₁₆ in. (9.2 x 7.1 cm)

67. CANYON DE CHELLY,
SUMMER 1932
Numbered *19* in Susan L. Sand-
berg's hand in pencil, verso
6⁷⁄₁₆ x 4½ in. (16.3 x 11.4 cm)
Private collection, West Bloomfield, Michigan

68. LOLA RIDGE, 1935
Signed and dated *c. 1925* by the
artist in pencil, with the artist's print-
ing notations and *MC-41-C* in pencil,
verso
3⅝ x 2¾ in. (9.2 x 7 cm)
Private collection, Amarillo, Texas

69. JUAN MIRABEL'S OVEN,
TAOS, SUMMER 1933
Signed and dated by the artist in
pencil, with *MC-76-C* in pencil, verso
6³⁄₁₆ x 4½ in. (15.7 x 11.4 cm)
Private collection, North Conway,
New Hampshire

70. BLUE CANYON ROCK
FORM, SUMMER 1932
Artist's printing notations in
pencil, verso; numbered *11* in Susan
L. Sandberg's hand in pencil, verso
3⅞ x 3³⁄₁₆ in. (9.8 x 8 cm)

71. GORDON GRANT, 1932
Signed and titled *Gordon Grant*
by the artist in pencil, verso; num-
bered *213* in Susan L. Sandberg's
hand in ink, verso
4¼ x 3³⁄₁₆ in. (10.8 x 8.1 cm)
Collection of Annie and Vince Carrino,
Portola Valley, California

72. KANSAS, SUMMER 1934
Titled *Kansas* by the author in
ink, verso; numbered *217* in Susan
L. Sandberg's hand in ink, verso
4⁹⁄₁₆ x 6¼ in. (11.6 x 15.9 cm)
Museum of Fine Arts, Houston

BEN LIFSON has written professionally about art since 1977, both as a photography critic for the *Village Voice* and as a contributor to many books. He has taught the history, theory, criticism, and practice of photography at Yale University, Harvard University, the University of California, San Diego, and the California Institute of the Arts in Valencia. A fine-arts photographer from 1967 to 1977, he has been awarded numerous grants for photography and criticism.
He lives in Hudson, New York.

RICHARD ELDRIDGE is principal of Friends Seminary in Manhattan. In 1987 he collaborated with Cynthia Kerman on a biography of Jean Toomer, *The Lives of Jean Toomer: A Hunger for Wholeness.* He has also published numerous articles, poems, and short stories.
He lives in New York City.

EUGENIA PARRY JANIS is a writer and in 1968 was the first art historian to develop and teach a college course in the history of photography. She taught at Wellesley College from 1968 to 1986 and at the University of New Mexico from 1987 to 1993. In 1973 she received a Guggenheim Foundation grant and in 1980 an American Council for Learned Societies grant, both to write about early French photography. In 1987 she was decorated by the French government as a Chevalier des Palmes Académiques for her contributions to the history of French art. Over the past twenty-five years, she has written numerous books and articles about art and the history of photography. In 1993 she received a National Endowment for the Arts grant in literature. Presently, she is writing a book on police photographs of violent crime in Paris around 1900. She lives in Santa Fe, New Mexico.

159

All the photographs published in this book were taken by Marjorie Content except for the photograph by Dorothy Norman on page 61, and figures 4, 5, and 29 and possibly the frontispiece (which might have been taken by Jean Toomer). Unless otherwise noted, photographs used as plates are courtesy of Jill Quasha, and photographs used as figure illustrations are courtesy of the Estate of Marjorie Content.

The tritone plates and the duotone figure illustrations are printed from film engraved by Thomas Palmer. All of the text in this book is composed in Monotype Perpetua.